a **lacquer** legacy
at **Kew**

LACQUER LEGACY

a lacquer legacy at Kew

THE JAPANESE COLLECTION OF JOHN J QUIN

 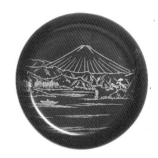

Hew DV Prendergast

Helena F Jaeschke

Naomi Rumball

Royal Botanic Gardens, Kew

2001

LACQUER LEGACY

© 2001 The Board of Trustees, Royal Botanic Gardens, Kew.

First published 2001

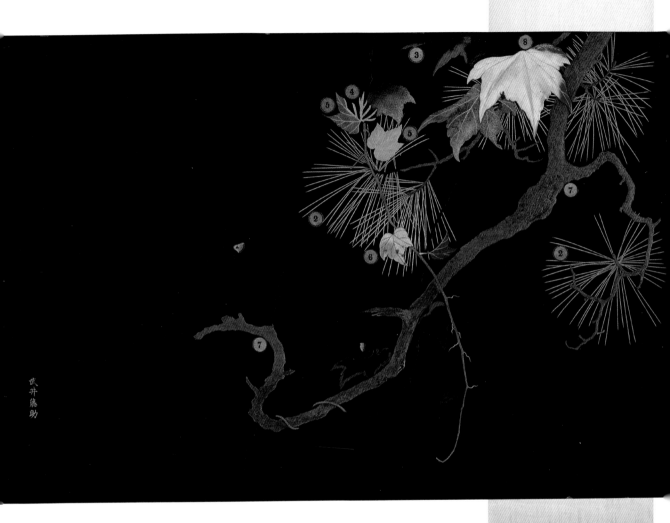

Design: Fiona Bradley, Media Resources

Production Editor: Suzy Dickerson

Information Services Department, Royal Botanic Gardens, Kew

ISBN 1 84246 018 8

Printed in Great Britain by Culver Limited

contents

foreword	1
acknowledgements	3
in Japan	5
opening to the West	5
botanical exploration	5
the British Legation	7
John James Quin	10
the varnish tree	13
botany and chemistry	13
distribution	16
the Kew connection	17
other interest	24
Quin's lacquer collection	26
contemporary Japan	29
Report by Her Majesty's Acting Consul at Hakodate on the lacquer industry of Japan	31
Catalogue of specimens forwarded	79
collection index	91
references	97

Lacquer Legacy

foreword

Like the attics of deceased and distant relatives, reference collections may conceal treasures seldom seen, often unvalued, and perhaps even forgotten about altogether. Although on public view with little interruption since 1847, the Economic Botany Collections at the Royal Botanic Gardens, Kew continue to startle. Among them is the assemblage of Japanese lacquer commissioned by Kew, made by John Quin under the auspices of the British Legation in Tokyo, and fully described in his own report that was published in 1882 (and is reproduced here in full). As fascinating as the lacquer itself is (dating back to the 1760s), there is far more to tell: of the opening of Japan in the mid nineteenth century and the rush there of the curious and adventurous; of the role of Kew at the height of Britain's imperial power; of the varnish tree, potentially poisonous yet with a gift in its sap that has become an important part of Japanese culture; and of the man himself, a clergyman's son from Ireland, who devoted his diplomatic career to a life in Japan. So this volume may have broad appeal: those who like lacquer and want to know more of an historically special collection and its origin, and others, more botanically minded, fascinated by the roles that plants may play in our lives, past and present, east and west.

Helena Jaeschke, Swimbridge, Devon
Hew Prendergast and *Naomi Rumball,* Centre for Economic Botany

Lacquer Legacy

acknowledgements

Grateful thanks are due to Mrs Vera Quin, who spotted the unusual single 'n' of Quin in the *Plants+People* exhibition at Kew and found that John had been her late husband's Great Uncle Jack; Nick Umney, Furniture Conservation Department, the Victoria and Albert Museum; Matt Quigley, Deans Grange Cemetery, Blackrock, Co. Dublin; Debbie Barney and Lucy Cuthbertson, Library & Information Services, and Nigel Jarvis, Records and Historical Services, Foreign & Commonwealth Office; Raymond Rafaussé and Susan Hood, Representative Church Body Library, Church of Ireland, Dublin; Bill Simpson and Jane Maxwell, Library, Trinity College Dublin; staff at the Public Record Office, Kew; Soichiro Negishi, Yokohama; Bill Judge, a Friend of Kew; from Kew, Peter Gasson (Anatomy Section, Jodrell Laboratory) and Tony Kirkham (Arboretum and Horticultural Services, Horticulture and Public Education Department); and finally Fumiko Ishizuna (now in Kew's School of Horticulture) and her mother, Nagako Ishizuna in Tokyo, who opened for us the possibility of starting this work. Andrew McRobb, in Kew's Information Services Department, took all the photographs (except where indicated).

LACQUER LEGACY

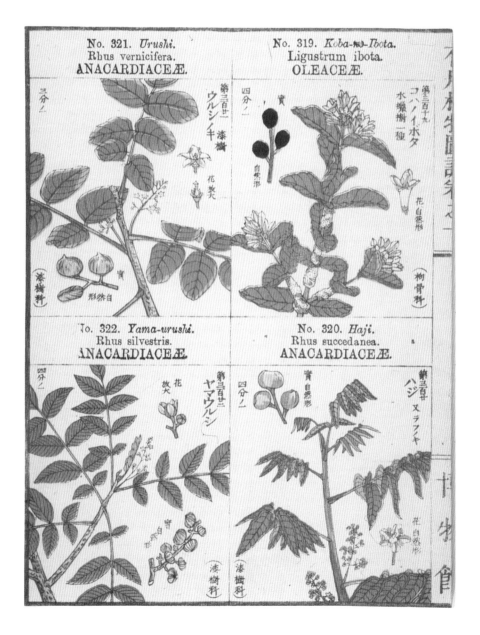

A portrait of the varnish tree (top left) in an 1891 Japanese volume on the *Useful plants of Japan* (Dai Nippon Nokai 1891).

in Japan

opening to the West

In 1854 Commodore John Perry arrived in Yeddo (Tokyo) Bay at the head of an American naval squadron. It was to prove a watershed in Japanese relations with the West. For two centuries only the Dutch, from their tiny island base of Deshima off Nagasaki, had been allowed to trade, but now other nations were vying for this right and to establish diplomatic relations. Perry, having delivered an ultimatum the previous year, succeeded on behalf of the Americans, and European nations were able to follow suit. The British Government immediately began looking for nominations to open a consular service in Japan[1] and by 1859 had put in place its first representative, Sir Rutherford Alcock. Japanese seclusion had come to an end.

botanical exploration

Despite restrictions, employees of the Dutch (such as the physician Engelbert Kämpfer in the 1690s[2] and Philipp Franz von Siebold in the 1820s[3]) had already provided glimpses of the botanical and horticultural wealth of Japan. By the 1850s a wave of new plant collectors was eager to explore further. Among them were Robert Fortune, who arrived in 1860 on behalf of The Royal Horticultural Society, and John Veitch, descendant of the founder of the famous Veitch of Exeter nursery. The Royal Botanic Gardens, Kew was also quick to act. In the wake of the British Government's presentation of a steam yacht to the Emperor, Kew, under the Directorship of William Hooker, sent its first collector, Charles Wilford, to Japan in 1857 and another in 1861, Richard Oldham, who sent back from Japan and Korea some 13,000 dried specimens for scientific study before he died in 1864[4]. These were just the first of Kew's diverse collections from Japan at this time. Others were to follow: a rich legacy of books, wooden panels illustrated with plants, the paintings of Marianne North and, finally, examples of some of the finest plant-based products of Japan such as paper and lacquer.

[1] Hoare 1997 [2] Stearn 1999 [3] Mac Lean 1978 [4] Desmond 1995

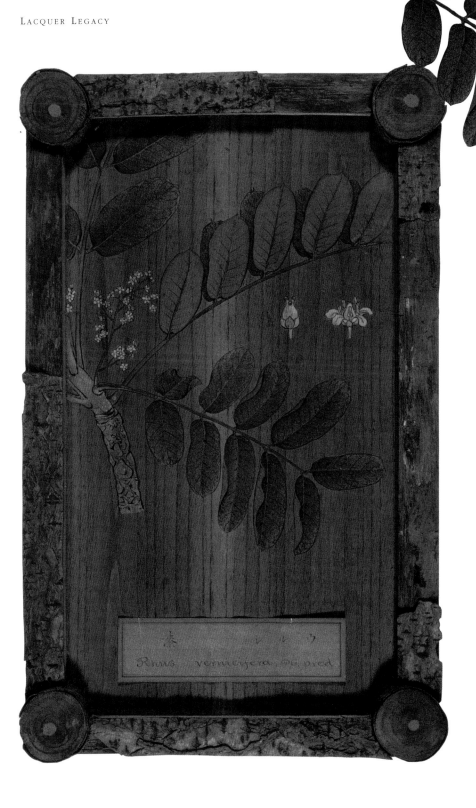

A varnish tree painted onto a wooden panel (Economic Botany Collections [EBC] 39998). In Kew's Economic Botany Collections there are 25 of these panels, closely resembling a larger collection held at the Botanisches Museum Berlin-Dahlem that has been dated to the 1860s and 1870s (Lack 1999). In most of the Berlin collection, the wood used is of the same species as the one illustrated. Who first acquired the Kew collection, and when, is not known.

IN JAPAN

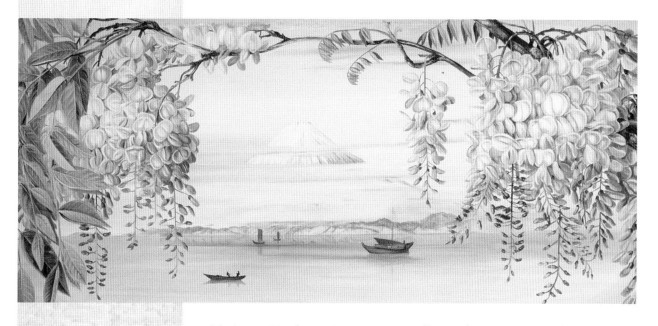

A view of Fujiyama, framed by *Wisteria sinensis*. This species, like the varnish tree, is of Chinese origin. Painting No. 658, in Kew's Marianne North Gallery.

Small round tray of Kaga lacquer featuring Fujiyama (see page 82).

Marianne North, an inveterate traveller and painter, arrived in Japan in November 1875. Despite suffering from rheumatic fever which curtailed her activities and, eventually, the length of her stay, she completed 16 pictures, including a *Wisteria*-framed view of Fujiyama. Along with the rest of her entire collection (832 paintings in all), these have been on display at Kew in their own gallery since 1882[1]. During her visit she paid her respects to the head of the British Legation in Yokohama, Sir Harry Parkes, and travelled with him on tour. He too left his mark – and not just at Kew.

the british legation

Although he is scarcely known in Britain, in Japan "it would be difficult to find anyone unaware of his name and his perceived role in the creation of the modern Japanese state"[2]. He had arrived in 1865 as successor to Rutherford Alcock, having already had a distinguished diplomatic career in China and been rewarded with a knighthood by Queen Victoria at the young age of 34. For the next 18 years he headed the British Legation, as Envoy Extraordinary, Minister Plenipotentiary and Consul-General, while Japan passed through civil war and took the first steps of

[1] Ponsonby 1990 [2] Daniels 1996

modernisation. Aside from better known accomplishments - the introduction of lighthouses into Japan, pensions for Samurai, surviving a dozen attempts on his life, and being the first foreigner to be granted a private audience with the Emperor[1] - he assembled a remarkable collection of paper and paper artefacts in response to a request from the Prime Minister, William Gladstone, for information on paper-making in Japan (see page 19). Many of these, based on plants such as the paper mulberry trees *Broussonetia papyrifera* and *B. kazinoki* (members of the same plant family as the fig, the Moraceae), came to Kew after Joseph Hooker (who succeeded his father as Director in 1865) had seen Parkes's *Reports on the manufacture of paper in Japan presented to both Houses of Parliament by command of Her Majesty*[2]. Scientific interest followed an economic one. The 'rediscovery' of the Parkes collection, initially in the Victoria and Albert Museum where the remainder is held, led to its eventual display in Tokyo in 1994[3].

The British diplomatic and consular establishment over which Parkes presided initially consisted of a staff of 22. Most were based in Yeddo while the rest were in other ports open to trade, such as Nagasaki and Hakodate. They were of variable backgrounds and skills and among them came the first British scholars of things Japanese[4]. Most were student interpreters whose main roles involved translation and the protection of the legal rights of merchants (Britain being the major trading nation at the time). New recruits, trawled from universities, were middle to upper class, often Irish in origin, and the sons of clergy[5] - and a typical example was John Quin.

[1] Webber & Thompson 1991 [2] Parkes 1871 [3] Webber & Thompson 1991; Anon. 1994; Webber 1995 [4] Daniels 1996 [5] Hoare 1997

The staff complement of the British Legation in 1868 (Public Record Office [PRO]: FO 46/260, 136). Sir Harry Parkes has been in position for three years while John Quin is in only his second year. Note also the presence of Alex von Siebold, one of the Dutch speakers recruited because theirs was the only Western langauge widely known in Japan. He was probably the son of Philipp Franz von Siebold (1796-1866) who was responsible for the import into Europe of huge quantities of living plants (Mac Lean 1978) - a precursor of the surge of interest in the Japanese flora that followed the country's opening up.

CONFIDENTIAL.

136

[Revised at the Foreign Office, June 1869.]

(A.)

GENERAL LIST OF THE JAPAN ESTABLISHMENT ON THE 31st OF DECEMBER, 1868.

Rank.	Name.	Place.	Date of Entry into the Service.	Date of Appointment to present Rank.	Remarks.
Envoy and Consul-General..	Parkes, Sir H., K.C.B.	Yeddo	June 1, 1842	Mar. 28, 1865	
Secretary of Legation	Adams, F. O.	Ditto	Feb. 1, 1854	Jan. 6, 1868	
Second Secretary..	Mitford, A. B.	Ditto	March 1858	Mar. 7, 1868	
Japanese Secretary	Satow, E. M.	Ditto	Aug. 20, 1861	Jan. 1, 1868	Absent on leave from February 24, 1869.
Interpreter and Translator..	Von Siebold, A.	Ditto	April 19, 1862	Jan. 1, 1868	
Assistant, Accountant, and Japanese Interpreter	Wilkinson, H. S.	Ditto	Aug. 22, 1864	Apr. 1, 1868	
Medical Officer ..	Siddall, J. B.	Ditto	Feb. 6, 1868	Feb. 6, 1868	
Consuls (5)	Eusden, R. .	Hakodate .	Jan. 17, 1859	Jan. 1, 1868	Date of first Commission as Consul, Feb. 1868.
	Fletcher, L.	Kanagawa.	Dec. 30, 1858	Jan. 1, 1868	Ditto. Jan. 1, 1868.
	Flowers, M. O.	Nagasaki..	Feb. 19, 1861	July 6, 1868	Ditto. May 3, 1867.
	Gower, Abel A.	Hiogo ..	May 27, 1856	July 6, 1868	Ditto. May 23, 1865.
		Neegata
Vice-Consuls (2) ..	Willis, William	Kanagawa.	Nov. 16, 1861	Jan. 1, 1868	One year's leave in the employment of the Japanese Government, granted February 9, 1869.
	Lowder, J. F.	Osaka ..	June 4, 1860	Jan. 1, 1868	Acting as Consul at Neegata.
Dutch Interpreters employed as Assistants (3)	Enslie, Jas. J.	Hiogo ..	Mar. 16, 1861	Mar. 16, 1861	Acting as Vice-Consul at Hiogo.
	Dohmen, Martin	Yeddo ..	Sept. 21, 1861	Apr. 1, 1864	
	Schmid, K. E.	Kanagawa.	Sept. 21, 1861	Apr. 1, 1864	
1st Assistants (2)	Annesley, A. A.	Nagasaki .	Feb. 12, 1859	Apr. 1, 1867	
	Walsh, P. B.	Kanagawa.	July 16, 1860	Jan. 1, 1868	On leave from February 24, 1869.
2nd Assistants and Interpreters (2)	Robertson, R. B.	Hiogo .	Feb. 4, 1860	2nd Assistant, Apr. 28, 1866 Interpreter, Jan. 1, 1868	Acting as Vice-Consul at Yedo.
	Troup, Jas.	Kanagawa.	Aug. 31, 1863	Jan. 1, 1868	
3rd Assistant and Interpreter	Aston, W. G.	Hiogo ..	Aug. 16, 1864	May 11, 1869	
Student Interpreters	Quin, J. J. ..	Hakodate .	Aug. 3, 1867	..	Acting as Assistant.
	Hodges, G. J. L.	Yeddo ..	Aug. 3, 1867		
	O'Driscoll, J.	Ditto ..	Dec. 24, 1867		
	Hall, J. C...	Ditto ..	Dec. 24, 1867		
	Longford, J. H.	Ditto ..	Feb. 24, 1869		

[263]

John James Quin

John James Quin was born on 2 February 1843, possibly in Armagh where his father Richard had been Vicar Choral of the Church of Ireland since 1834[1]. He was the second of three brothers (the others being Thomas and Richard) and had two younger sisters (Emily and Edith). The most eminent of his forebears was his great grandfather, Henry, who, after a medical education in Padua, became President and Fellow of the King and Queen's College of Physicians in Ireland, King's Professor of the Practice of Physics, and a prosperous patron of the arts, entertaining distinguished visitors to Dublin such as Georg Händel and Canaletto[2]. One of Henry's sons, also Henry, became a noted bibliophile who bequeathed his collection, the Bibliotheca Quiniana, to Trinity College Library in 1805[3] where to this day it retains the position he specified in his will.

Little is known of John Quin's formative years. There is no admissions or graduation record of him at Trinity College, Dublin in contrast to many of his antecedents, including his father who studied there in the 1820s[4]. His father became Vicar of Forkill, Dundalk, Co. Louth in 1858, and died and was buried there in 1886. It was from there, on 25 August 1867, that John wrote to the Foreign Office confirming that he had received tickets for his passage from Southampton to Yokohama on a Peninsular and Oriental Company's

QUIN, JOHN JAMES,
passed a competitive examination, and was appointed a Student Interpreter in Japan, August 3, 1867. Was promoted to be a 3rd Class Assistant, August 23, 1869; a 2nd Class, January 1, 1872, and a 1st Class, April 1, 1873. Was Acting Consul at Hakodate from October 1, 1880, to February 18, 1883. Was promoted to be Her Majesty's Vice-Consul at Tokio, August 6, 1882. Was nominated, provisionally, Consul for Hakodate and Neegata September 9, 1884; and was appointed to those posts, May 20, 1886. Was Acting Consul at Yokohama from June 4 to September 24, 1888; and at Hiogo from September 28, 1888, to February 18, 1889. Was transferred, as Consul, to Nagasaki, October 1, 1888. Retired on a pension, November 11, 1896.

The official record of John Quin's Foreign Office career (from Hertslet 1897).

[1] Leslie 1911 [2] Mrs Vera Quin pers. comm. [3] Morrow 1986
[4] Jane Maxwell Old Library, Trinity College, pers. comm.

> 9 Crosthwaite Park W
> Kingstown
> Co Dublin
> 14th October 1896
>
> My Lord
>
> I have the honor to request your Lordship's permission to retire from the Japanese Consular Service on the pension attached to my appointment and to resign my post as her Majesty's Consul at Nagasaki, on the grounds of serious illness.
>
> Your Lordship may remember that in August last, I returned from Japan on sick leave, and I had hoped that a sojourn at Home would have restored me to health, but the enclosed medical certificates will show you that two such eminent physicians as Doctors Whipham and Venning certify that my return to Japan is impossible.
>
> I also enclose a further certificate from my medical adviser here, who is fully of the same opinion as the other doctors. Under these circumstances I see no reason for any further delay in making an application to retire on pension from the service at as early a date as possible; as it will enable your Lordship to make such arrangements to fill the vacancy, as may be necessary.
>
> I have the honor to be, with the highest respect,
> My Lord,
> Your Lordship's most obedient and humble servant
>
> John J Quin
>
> The Rt. Honble
> The Marquis of Salisbury K.G. etc.
> Foreign Office.
> London.

Quin's letter of resignation, on the grounds of ill-health, written from Kingstown (now Dun Laoghaire), where he died in 1897 (PRO FO 46/476, 123).

steamer[1]. What was expected of him on arrival in Japan is clear from a letter sent to two other Irishmen also embarking as student interpreters on a career in Japan at the same time, John O'Driscoll and John Hall. "You will understand that the primary object for which you are appointed is that you should study the Japanese language so that hereafter you may be qualified to discharge any duties for which you may be selected, but you will also not fail to take advantage of such opportunities as you may have for acquiring an insight into the manner in which the service of H.M. Diplomatic & Consular Establishments in Japan is carried on"[1]. The salary was £200/year.

[1] PRO FO 46/84

John Quin spent his entire career in Japan, interrupted by long spells of leave. In December 1870 he married Laura Isabella Ruxton (from Ardee in Co. Louth) who, according to family history, was eventually to die at sea on the way home[1]. In January 1875, he wrote from Forkill Rectory requesting an extension of leave on the grounds of (unspecified) "ill-health" . Whether this was connected to the "serious illness" he offered as cause of his eventual resignation from the Foreign Office in October 1896 is unknown but he died just months later, on 2 February 1897. He was buried in Deans Grange Cemetery, near Dun Laoghaire in Co. Dublin, close to his last known dwelling, 9 Crosthwaite Park West.

His interest in lacquer aside, of Quin the person little surfaces in either family history, that relates merely that he maintained a deep interest in the Ainu people of Hokkaido[1], or his official correspondence. However, from those letters he wrote immediately prior to his resignation, one senses a keen sense of humiliation and injustice that a post at Kobe was offered to John Hall and not to him[2]. He thought that his lack of legal training and his absence from Japan on health grounds were being used as excuses, which of course they probably were. But Quin's premature retirement was by no means unusual. Stress, sickness, and isolation were widespread among Britain's consular staff in Japan, and 'unhealthy' posts such as Nagasaki, Quin's last, attracted added years for superannuation purposes[3]. Death at 54 denied Quin any retirement. Childless, and hitherto posthumously neglected, he left behind a meticulously recorded collection of one of Japan's finest arts, the use of lacquer. Today he lies among many others who, like him, had spent most of their lives overseas.

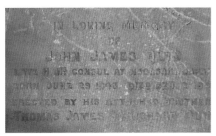

Quin's grave in Deans Grange Cemetery, Co. Dublin.

H.D.V. Prendergast

[1] Mrs Vera Quin pers. comm.
[2] FO 46/476,118 [3] Hoare 1997

The varnish tree growing wild in woodland in Bazhong Prefecture, Sichuan, China, at an altitude of 1625 meters. The trunk has been cut for lacquer (compare with pattern on page 30). The picture was taken on a Kew plant collecting expedition in 1999.

A. Kirkham

the varnish tree

botany and chemistry

Most lacquer derives from the sap of plants in the same family, the Anacardiaceae, as the cashew, mango and pistachio. The Burmese lacquer tree *Gluta usitata*, for example, is the source for work in Burma[1]. Overall, however, by far the most important species is the varnish tree *Rhus verniciflua* (also known in the past as *R. vernicifera*).

There are about 200 species of *Rhus*, occurring mainly in North America, southern Africa, eastern Asia and Australia. Many of them, like the sumachs *R. copallina* and *R. typhina*, are well known to horticulturalists for the colours of their autumn foliage or attractive fruits while others, often classified as *Toxicodendron*, are notoriously toxic. In North America about 50% of adults are sensitive (and 10-15% *very* sensitive) to the poison ivy *T. radicans*. The sap of this common woodland plant contains urushiol, an alkyl catechol that in its natural state is relatively stable but in the presence of oxygen in tissue typically causes intense and painful dermatitis. Even indirect contact with the plant, for example via other people or pets, is sufficient to produce symptoms, with repeated exposures producing an increasing severity of effect[2].

The varnish tree itself (*urushi* in Japanese) also contains the chemical, in lesser but still potentially harmful amounts. "For many years a large specimen of this tree grew in Hillier's old West Hill Nursery at Winchester where it was admired by all who saw it. One autumn the leaves turned a rich-bronzy-purple and the then nursery foreman decided to cut a few branches for an exhibit at one of the Royal Horticultural Society's shows. Before the end of the day, the skin of his arms and face was beginning to itch and by the following morning he was in agony, his arms, face and neck red and swollen. In the end he had to go to hospital and it was a month or more before he was fit

[1] Isaacs & Blurton 2000 [2] Dauncey *et al.* 2000

enough to resume work"[1]. The felling and subsequent burning as firewood of a varnish tree in what must be one of the biggest plantings of the species in Britain, in an Oxford housing development, caused acute contact dermatitis among eight people. Particularly badly affected was an elderly woman who had previously been sensitised by exposure to poison ivy in the USA[2]. Not surprisingly, the authors of this report thought the varnish tree an unwise choice for a public planting scheme.

Not just the tree causes problems. Robert Fortune[3] described how a friend of his in China, the "American Consul at Foo-chow-foo, used some furniture which had been lacquered some time and was apparently dry, and yet was very ill for a long time from its effects; so ill he thought he should be obliged to leave the country and go home." A visitor to Japan[4] described the symptoms of lacquer poisoning during processing: "It is a peculiar, not very painful, and not at all fatal, but always very disagreeable disease, always attacking one new to the work, whether he be lac-tapster, dealer, or lacquerer. It appears in a mild reddening and swelling of the back of the hands, the face, eyelids, ears, the region of the navel and lower parts of the body, especially the scrotum. In all these parts great heat is felt and

Foliage and flowers of a varnish tree at Kew.

A spectacular display of autumn colour from Rhus trichocarpa, growing wild in forest in Hokkaido, Japan. A Kew plant collecting expedition in 1997 obtained seeds of this species for cultivation. It also grows in China and Korea.

A. Kirkham

[1] Lancaster 1989 [2] Powell & Barrett 1986 [3] Fortune 1857 [4] Rein 1889

Cross section of part of a stem of poison ivy. Clearly visible near the bark are large, oval shaped resin canals that characterise the family of plants to which it and the varnish tree belong. It is the cutting of these canals that leads to the flow of the resinous lacquer.

H.D.V. Prendergast

Chemical formula of urushiol ($C_{21}H_{32}O_2$) (from Harborne and Baxter 1996).

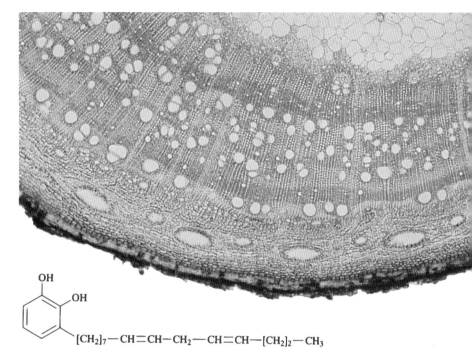

violent itching and burning, causing many sleepless nights. In two or three days, the crisis is reached, and the swelling immediately subsides. In severe cases, small festering boils form also." Avoiding inhalation of the vapour and wearing mittens helped prevent any reactions.

Any intense reaction to the hardened lacquer itself is, however, most unusual. Its remarkable chemical stability did after all lead to its widespread use as a protective and decorative coating for wood and bamboo food containers, especially bowls and boxes for soup and rice, as well as the delicate utensils for the tea ceremony. Repeated use and cleaning poses no risks either. Indeed, in the case of the red lacquer bowls made and used by the monks of temples at Negoro in Naka, this led to a style of lacquering with black rims, named *Negoro-nuri*. Quin traced the history of this ware in an article which he had first read to the Asiatic Society of Japan on 12 October 1880 (and was published the following February[1]). and later included in his collection a tray of Negoro ware which was over 50 years old.

[1] Quin 1881

distribution

As a wild plant the varnish tree occurs throughout China (except the northeast), up to an altitude of 3800 metres[1]. Traditionally it is supposed to have been introduced to Japan for its lacquer in the third century AD, although lacquered objects (possibly derived from it) have been found dating from at least the third century BC[2]. Lacquered objects reached Europe via the Portuguese who had started trade with Japan in the 1540s; and it was a Portuguese Jesuit, Alvarus de Semedo, living in China from 1613 to 1658, who made the first reference by a Westerner to the tree itself[3]. Another Jesuit introduced the species to Mauritius (Isle de France) in 1766 and by 1862 at the latest it had reached gardens in Europe[4]. In the 1830s, however, if his identification of the plants was correct, the French novelist Honoré de Balzac made at least three references to the lacquer tree, as in "une allée d'acacias et de vernis du Japon" in *Le lys de la vallée*. Robert Fortune encountered the tree in China during his botanical travels in the mid-1850s. Foreshadowing a connection between Quin and India a quarter of a century later, he had been asked by the Agricultural and Horticultural Society of India "for any assistance I could render them in the way of sending the society seeds and plants of useful and ornamental trees and shrubs which were likely to be of value to India"[5], among them the varnish tree. Curiously, he did not refer to the varnish tree when he later visited Japan, although he did note that "the modern lacquer-ware is good"[6], nor did he indicate in his books that there was any interest in cultivating the plant in Britain. In European horticulture it is today described (under *Toxicodendron vernicifluum*) as a Zone 9 species, able to grow in areas with a range of average annual minimum temperatures of -6.6°C to -1.2°C[7] - a climatic boundary that encompasses most of the UK. However, it is not nearly as popular as other species of *Rhus*; indeed there is but a single supplier of plants in the whole country[8]. The UK's tallest specimen, at Westonbirt House, Gloucestershire, is recorded as 21.5 metres high and having a diameter of 70 cms at chest height[9].

[1] Cheng Mien & Ming Tien Iu 1980 [2] Kidder 1959; Nakasato *et al.* 1971 [3] Bretschneider 1898 [4] Hillier Nurseries 1996 [5] Fortune 1857 [6] Fortune 1863 [7] Huxley *et al.* 1992 [8] Royal Horticultural Society 1997 [9] Mitchell *et al.* 1994

the Kew connection

William Hooker.

The start of Kew's involvement with lacquer lay in the dual interests in the taxonomy and uses of the plant kingdom that strongly characterised Sir William Hooker. He had established, and put on show, the Economic Botany Collections at Kew in order "to render great service, not only to the scientific botanist, but to the merchant, the manufacturer, the physician, the chemist, the druggist, the dyer, the carpenter and the cabinet maker and artisans of every description, who might here find the raw materials employed in their several professions correctly named." Sharpened by his travels[1], his son Joseph inherited these interests. In his monumental *Flora of British India*, he finally put to rest any confusion that had previously existed about the precise identity of the varnish tree when he wrote that an Indian species was "quite distinct" from it[2]. Just how little had been known in Britain at the time is shown by a letter of 14 February 1883 from William Thistleton-Dyer (who was to succeed as Director in 1885) to Sir Louis Mallet at the India Office: "From the statement of Kämpfer (1712) it has been accepted by botanists that the varnish which is the basis of all lacquer-work was obtained from incisions in the three-year old stems of a tree indigenous to Japan." It was also known that the tree was coppiced but beyond that, it was claimed, "knowledge on the subject has been a complete blank"[3].

That there had in fact been some literature published on lacquer production is shown in an internal memorandum of March 1881 that is the first indication of Kew's specific interest in the plant and its product: "Please look this up," it states under the heading "Japan varnish", "and say what illustrative specimens are desirable for the museum". The answer referred to an 1871 paper published in the Journal of Applied Science, and made recommendations for what should be acquired for Kew's Museum of Economic Botany. Coincidentally perhaps, an unsigned, unheaded letter, accompanied by some seeds of the varnish tree, had arrived at Kew in May from Yokohama. Other seeds, it said, had been sent to Ceylon "as it may become a new source of profitable industry in the Colony".

[1] see Desmond 1999 [2] Hooker 1879 [3] Kew Archives, *Miscellaneous Reports. Japan. Lacquer. 1881-1902*. This volume, and PRO FO 46, are the sources for all the correspondence referred to here.

On 6 August 1881 Thistleton-Dyer wrote to Sir Julian Pauncefort at the Foreign Office. It is a letter resonant with Kew's imperial role as the great entrepôt for global botanical exploitation and development. It also displays both an awareness of the need to please those prepared to finance Kew's activities, and a care in its diplomatic praise for the previous efforts of the British Legation in Japan, that were necessary to help carry out such a role.

> "Sir,
>
> I am desired by Sir Joseph Hooker to ask your kind permission in procuring though HM's legation in Japan the undermentioned specimens for the Museum of Economic Botany of the Royal Gardens.
>
> It appears that in 1873 Professor Rein of Marburg was sent by the Prussian Ministry of Finance and Commerce to Japan to report upon various local industries including a well-known lacquer manufacture.
>
> There are, however, no specimens whatever in the Kew Museums, illustrating this very interesting industry.
>
> Sir Joseph Hooker however thinks that if some member of the British Legation in Japan would kindly interest himself in the subject there would be little difficulty in obtaining the following specimens.
>
> 1. A piece of the trunk of the varnish tree Rhus vernicifera not less than a foot in length showing the mode of incising the bark.
>
> 2. Specimens of the varnish as obtained from the tree and also after the various processes of refining.
>
> 3. Pieces of work varnished with the material so obtained and also others showing different stages of manufacture.
>
> 4. Peculiar bow shaped knife used by the tapper.
>
> 5. Bristle-pencils used by the lacquer-workers.
>
> I am to add that Sir Joseph Hooker is particularly anxious to obtain these specimens. The Kew Museums having been largely increased at the cost of the India Office an effort is being made to render them as complete and representative as possible of the useful application of substances derived from the vegetable kingdom. A new guide is being prepared to be issued by the English government which it is hoped will afford a classified digest of useful products which will be found of

Joseph Hooker.

Paper made of paper mulberry in imitation of leather for book binding, one of the Parkes collection (EBC 42873).

Lacquered bowl made from bark of the paper mulberry, donated by J.H. Veitch in 1893 (EBC 45848).

THE VARNISH TREE

Kew's Museum of Economic Botany, founded in 1847 by William Hooker to exhibit the Economic Botany Collections and now usually known as Museum No. 1.

great service to British colonists and residents abroad in directing their attention to new industries.

I may add that we possess at Kew a portion of the collection illustrating the paper-manufacture of Japan made in 1871 under the direction of Sir Harry Parkes. This collection has been frequently examined with the greatest interest by leading paper-makers in the country and its utility at Kew amply rewards the great pains which must have been expended by the members of the Japanese Legation in getting it together."

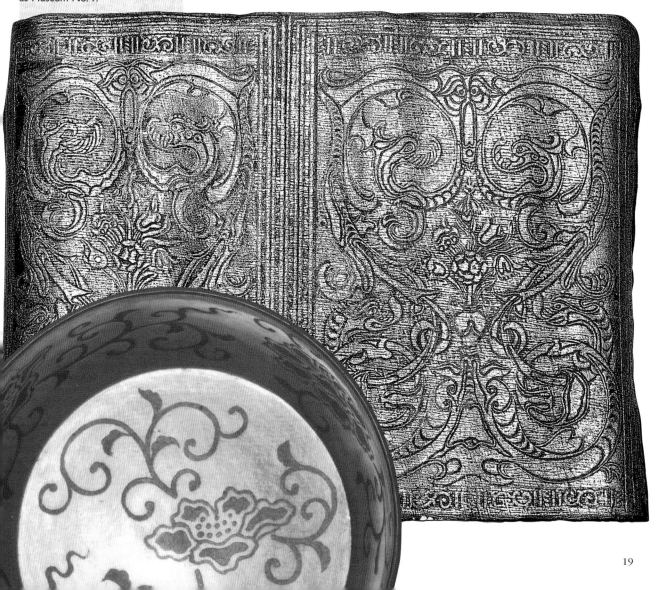

By the end of August the Foreign Office wrote back to Thistleton-Dyer that "Her Majesty's Chargé d'Affaires in Japan will be instructed to procure and forward to this country the various specimens indicated by you illustrative of Japanese lacquer work."

The Kew Archives (for example a letter from Quin to a superior of his in the British Legation, J.G. Kennedy) show that in December 1882 Quin happened to be on leave in Tokyo. "Owing to his thorough knowledge of the Japanese language and to his previous study of the lacquer industry" (namely the paper he had read to the Asiatic Society in October 1880), as Kennedy later wrote

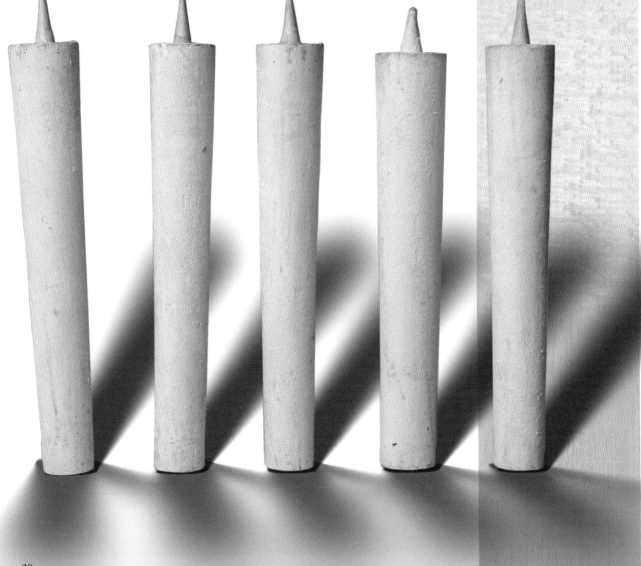

Wax candles made from the fruits of the varnish tree, part of Quin's second batch of collections sent in 1882, and not referred to in his report (EBC 62104).

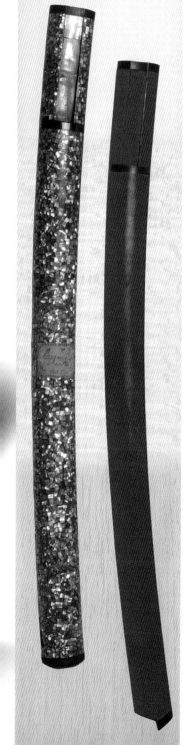

Inlaid shell and red lacquered sword sheaths, also part of Quin's second batch. They are probably made from a species of magnolia (see page 43) (EBC 67838, 67837).

to Earl Granville at the Foreign Office (on 23 January 1882), Quin was the obvious candidate for making the collection wanted by Kew. By 13 January 1882, Quin had not only completed the task, but also written the report that Lord Granville later sanctioned should be published as a Parliamentary Paper (reproduced later). By June the collection was at Kew, the whole exercise having cost £71-14-6 (with a later additional charge of £3-5-4).

Kennedy praised the "industry and zeal" of Quin and, just as he had been by the efforts of Sir Harry Parkes on Japanese paper-making years earlier, Hooker too was deeply impressed by Quin's report and the collection that was destined for Kew's Museum of Economic Botany. On his behalf a letter (12 July 1882) was sent to the Foreign Office, stating that

> "The Collection far exceeds in interest, importance and completeness anything which Sir Joseph Hooker had thought possible could be got together in connection with the subject. They are exhibited in a prominent position in Museum No. 1 where they excite much interest among the visitors. They have also been examined by several persons who take especial interest in the objects and processes and a high opinion has been expressed both as to the artistic and technical value of the collection".

The letter further expressed a debt of gratitude to Quin and asked him to procure further items, not just some seeds and berry wax of the varnish tree, and examples of lacquered sword sheaths (none of this second batch is included in his report), but also items made of other plants such as *Ginkgo biloba*. At the end of 1882 (letter of 28 December), Quin wrote to say how pleased he had been by Kew's reception of his report and collection, and how he had applied – unsuccessfully - to Sir Harry Parkes for leave to get more specimens. He sent the second batch (that cost £10–17-1) on 22 March 1883 and on 19 May, no doubt on leave, he called in at Kew where, since he did not manage to meet Hooker, he left a note saying that he had brought some young plants of the varnish tree that he had dug out of the snow in Hakodate.

Quin's report set in train a series of events typical for many useful, or potentially useful, plants handled by Kew at the time. Thistleton-Dyer wrote to Mallet extolling the merits of introducing the varnish tree to India as an alternative to the insect-derived lac used there: "Its results", he wrote on 16 February 1883, "are, in an economic point of view, infinitely superior to those in which lac is used". In March Quin's report was forwarded by the Under Secretary of State for India to the Viceroy "in order that attention may be drawn to the subject in India" and in June seeds of the varnish tree were distributed not just to India (Madras and Saharanpur) but also to Jamaica, Grahamstown (Cape Province, South Africa), Hong Kong, Tasmania, Cambridge (both England and USA), Edinburgh and Dublin. Some of the Indian batch went to the Government Plantations in the Nilgiri Hills, the very same planting site as for one of Kew's most famous plant transfers of all, that of quinine (*Cinchona*) from Peru, introduced to India against malaria. That venture, whilst not a total success, nevertheless had "enhanced Kew's reputation by confirming its dominance in the botanical activities of the Empire, and also its ascendency over colonial botanical gardens which increasingly looked to Kew's director and staff for guidance and support"[1]. The varnish tree similarly did not flourish. By 1892, with plants showing slow growth and requiring great care, *A dictionary of the economic plants of India*[2] was saying "It seems ... very doubtful if the high expectations which were at first formed of establishing a lacquer industry in India, similar to the Japanese one, will ever be fulfilled, unless some of the indigenous species are found to serve the same purpose". None was, and furthermore there was the difficulty of replicating the Japanese "passion for finish" in lacquer work.

As Hooker already knew, Quin had not been the only European to study lacquer production and processing. Prof. J.J. Rein, by this time Professor of Geography at the University of Bonn, published an extensive account of *The industries of Japan*[3] which included 40 pages on lacquer and a mention of earlier published works. Among these were Quin's report and a paper titled *Mémoire sur la vernis de la Chine*, written by the Jesuit Father d'Incarville in

Map from Rein (1889) showing the distribution of the varnish tree and its relative *Rhus succedanea*, the source of a wax that is still exported from Japan. Asterisks highlight the three main prefectures of present-day lacquer production.

[1] Desmond 1995 [2] Watt 1892 [3] Rein 1889

THE VARNISH TREE

JAPAN:
MAP SHOWING THE DISTRIBUTION OF
THE TALLOW AND LACQUER-TREES.
Scale 1: 8.500.000

▨ Distribution of the tallow-tree (Rhus succedanea L.)
▨ " " " lacquer-tree (Rhus vernicifera D.)
╱ Boundary between the tallow & lacquer districts.
The places named have notable lacquer-industries
Intensity of color indicates more marked cultivation
of the trees.

1760. Rein pointed out the similarity between the Chinese and Japanese methods, but made no reference to Kämpfer's observations. He himself had spent the first five months of 1874 studying lacquer and, like Quin, made a comprehensive collection which, he wrote, "in the nature of its origin and its instructive value may be truly said to stand alone". He sent it to the Royal Industrial Art Museum in Berlin. In a further footnote Rein stated that both Joseph Hooker and Quin "appear to have as little knowledge of the above quoted works of Father d'Incarville and Dr. Wagener as of my own study of lacquer work in Japan". Did this reflect national rivalry, his own real assessment of the value of Quin's observations, or was it a personal antipathy born in the small world of resident westerners? Whatever the case, Rein followed his investigations in Japan with more in Europe. He visited Kew (and left his card) in September 1891 to report on the varnish trees he had grown from seed in Frankfurt Botanical Garden. Based on them, he was hoping not only to tap high quality lacquer but also to introduce from Japan the skills and craft of lacquering. As in India, there is little evidence of fruitful results.

other interest

Apart from physicians dealing with the consequences of contact with the varnish tree, other disciplines have since been attracted to the sap: plant anatomists, for example, studying the cells through which it is excreted by the tree[1] and chemists and others analysing compounds such as urushiol[2]. The first analyses attempted in Britain appear to have been those carried out on behalf of the Irish scientist Robert Boyle (1627-1691) of Boyle's Law fame ("the pressure of a gas varies inversely with its volume at constant temperature") for the Royal Society for Improving Natural Knowledge. Boyle may have become interested in lacquer whilst a director of the East India Company. Although scientific knowledge was advancing rapidly at the time, the inert nature of the polymerised lacquer probably contributed to the failure of the tests[3]. More recently, fraud squads and archaeologists have benefited from spectrometric analyses of lacquers that can distinguish real from fake and old from new[4]. One avenue of research that remains a mystery, however, concerns work at

[1] Zhao & Hu 1989 [2] Kenjo 1988; Kumanotani 1988; Jaeschke 1992
[3] Huth 1971 [4] Burmester 1983

Kew during the Second World War. Correspondence states that the varnish trees growing in the Gardens during the War were tapped. In response to an enquiry, a Kew botanist[1] wrote that "No chemical tests were made on the material at Kew, and I never heard the results of the tests that were made elsewhere as much secrecy surrounded the whole subject at the time. I do remember, however, that the material was sent to the military research station at Porton near Salisbury". What the cause of such secrecy was can only be guessed, especially as there appear to be no records at Porton itself[2].

Letter of CR Metcalfe.

> *Rhus verniciflua.*
>
> Rhus verniciflua was tapped at Kew early in the second world war, at the request of Sir Arthur Hill. The bark of Rhus toxicodendron was collected at the same time. No chemical tests were made on the material at Kew, and I never heard the results of the tests that were made elsewhere as much secrecy surrounded the whole subject at the time. I do remember, however, that the material was sent to the military research station at Porton near Salisbury, from whom further information might be obtained. Correspondence at registry?
>
> I have no doubt we could collect a further sample. It entails putting a temporary fence round the tree or trees to be tapped in order to keep the general public away. Furthermore it is desirable to wear rubber gloves and an old mackintosh to protect one's skin and clothes. It is also desirable to collect the material when the weather is cool, so that it is less liable to injure one's skin.
>
> Sgd. C. R. Metcalfe.
> 18 – 7 – 51.

[1] Letter of CR Metcalfe, 18 July 1951, Anacardiaceae box file 2; Economic Botany Library, Kew.
[2] Sue Ellison, Chemical and Biological Defence Sector, Defence Evaluation and Research Agency, Porton Down, pers. comm.

Quin's lacquer collection

Quin's collection of 170 numbers (some of which contain more than a single item) and its accompanying report[1] provide an excellent introduction to the Japanese methods of producing and decorating lacquerwares, from the cultivation and tapping of the trees, through the treatment of the sap and the preparation of the bases, to the application of the decorated layers and the final polishings. Although lacquer can be applied to a variety of bases, including metal represented by catalogue no. 135 in his collection (see page 58), Quin concentrated on lacquering on wood. He included the tools used at each stage (except the large vessels and stirrers used for boiling the sap) and samples of each of the constituents, including fillers, pigments and diluents. Each stage is accompanied by Quin's detailed notes, describing nearly a hundred different formulations and mixtures of *urushi*, and commenting on their use and suitability.

For example, the collection includes samples of the additives to be mixed with *urushi* in foundation layers, such as coarse and fine burnt clay, chopped hemp fibre and whiting. In the report Quin added details about some of the ingredients, noting that shells from ancient middens were used for making *go-fun* whiting (a form of calcium sulphate used by artists to make gesso and a white underlayer for paintings) and that lampblack (carbon black obtained from oil lamps, as opposed to soot from fires which has a larger particle size and slightly different contaminants) was used in better quality items, ordinary soot being used in inferior items. Quin also noted that the cuts on the tree trunks do not follow exactly the pattern described in his text, as each craftsman tends to vary his procedure slightly. This attribute he noted also in the manufacture of lacquered items, where it may give rise to considerable differences in the production of outwardly similar items. This observation is vital to those examining lacquered items today, enabling quirks in manufacture to be distinguished from later repairs.

[1] Quin 1882

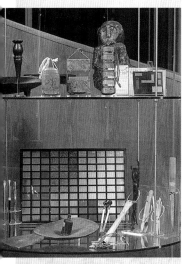

Some of Quin's collection on display in the *Plants+People* exhibition in Kew's Museum No.1.

Quin described in great detail several of the most frequently used processes of producing a lacquered item, illustrating them with eleven sample boards (e.g. no. 127) showing each stage in the production of different qualities of black, red and coloured lacquers. Curiously, although lacquer decorated with gold and silver powders and flakes was extremely popular in Europe at that time, and was described in detail by Quin, he made no separate collection of them as he did for the (cheaper) tin (nos. 125, 125A). A significant proportion of the report and the collection was devoted to the manufacture of items entirely covered with a metallic finish and to those with a flat or raised metallic decoration. Several paper patterns were included, along with a range of brushes and associated fine tools used for applying and building up the designs.

To complete the collection, Quin included several complete modern pieces and others that were even then antique. These were cross-referenced with Quin's earlier article[1] on the historical development of lacquer production, so that even greater detail regarding different techniques used in different areas or developed by individual craftsman could be included. The two articles and the collection together provide a detailed and practical guide to Japanese lacquering.

Quin was greatly concerned at the state of lacquer production in the 1880s and the effects of changing economic and social pressures. In particular he feared that the methods that had been refined over centuries were being abandoned in favour of cheaper materials and quicker setting mixtures of lacquer. He attempted to give the world a picture of a great craft, afraid that he was seeing it in its last great flowering.

The importance of Quin's collection results in the detailed picture it presents of the methods used at the end of the 19th century and earlier. Thanks to him we have a snapshot showing what was being done, how it was being done and the tools and materials being used. As well as providing a detailed source

[1] Quin 1881

of information, the collection forms an extremely useful series of specimens to compare with other lacquers that we have today. As the complex process of polymerisation is slowly unravelled, the differences in the composition of the original sap are thought to be vital contributors to the appearance and stability of the lacquer. Quin's collection provides samples of materials, including unpolymerised sap, which will enable more to be determined about the processes of formation and deterioration of the lacquer film.

However, the collection also provides us with a valuable database of materials that can be analysed and recorded. The size and shape of the particles of pigments and fillers can provide vital clues to the age, quality and origin of lacquered items. Only tiny fragments from the edge of cracks or breaks are needed to provide a thin-section that allows us to see the detailed structure of the piece[1]. The Quin collection is a window on the past, but it is also a database for the future. The items do not appear to have been conserved or treated since they were received at Kew. Some, particularly the small hand-tools, have been mounted in small cardboard trays, probably for display at some time or other in Kew's Museum No. 1. They have received a small amount of handling and have accumulated a small amount of grime from the atmosphere over the years. While a few of the lacquered objects were described by Quin as 'worn', and several now have cracks and some have areas of loss, generally they are in excellent condition. A selection of them is now in its third century of exhibition in Museum No. 1.

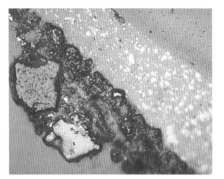
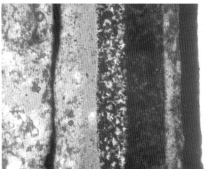

Cross section of red lacquer showing the particles of cinnabar pigment in the lacquer above clear layers and foundation.

H. F. Jaeschke

Cross section of red and gold lacquer viewed by reflected light. The black layers are foundation and tiny particles of gold, and gold alloy can be seen in the pigmented red layers.

H. F. Jaeschke

[1] Jaeschke 1985

contemporary Japan

Of course continued interest in lacquer by artists and craftsmen depends on the production of the raw material in the first place. The varnish tree is still cultivated and tapped in Japan. During a season that lasts from June to November, tappers harvest about 300 ml of raw lacquer from each of the 400 – 500 trees they tend (compare Quin's statement in his 1882 report that "a good workman is expected during the season to tap an average of 1,000 trees ten years old"), a process best carried out in the early morning. Japanese lacquer is considered to be of the best quality because of its high concentration (70%) of urushiol[1] but local supply does not meet demand and competes with cheaper imports. Production in 1998 was just 2.5 tonnes, 90% of it in the three prefectures of Iwate (the main source), Ibaraki and Niigata (see page 23). Imports on the other hand amounted to 192 tonnes, with China by far the greatest supplier, followed distantly by Vietnam[2]. As with many plants worldwide that sustain traditional and locally distinctive crafts and products, the varnish tree is affected by an increasingly global economy. In Japan it has declined but the work of craftsmen and artists is increasingly valued and new generations are producing modern as well as traditional designs. The Japanese Government awards a few of these consummate artists the title of National Living Treasure, honouring the knowledge and skill they hold. "The great drawback", Quin observed, "to making lacquer ware of a high order in the present day consists in the fact that the workmen cannot afford the time necessary, but are obliged to work as rapidly as possible. In former days time was no object"[3]. It is fortunate that he, at least, had the time - over a few weeks starting in December 1881 - to make his collection and complete the accompanying report.

[1] Arakawa et al. 1997 [2] all figures from the Japanese Ministry of Agriculture, Forestry and Fisheries, and Ministry of Finance [3] Quin 1881

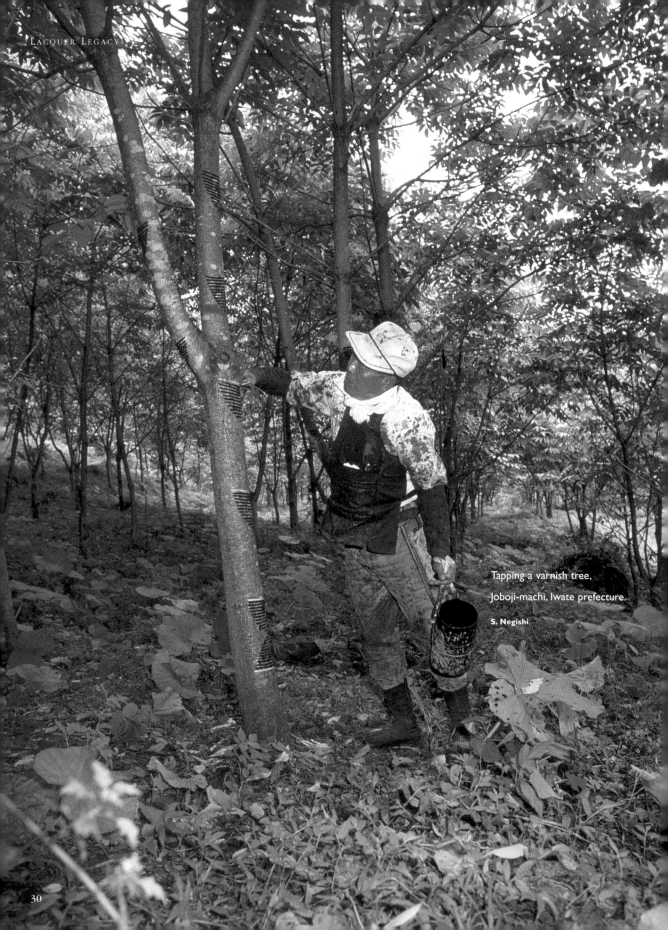

Tapping a varnish tree, Joboji-machi, Iwate prefecture.
S. Negishi

JAPAN. No. 2 (1882).

REPORT

BY

HER MAJESTY'S ACTING CONSUL AT HAKODATE

ON THE

LACQUER INDUSTRY OF JAPAN.

Presented to both Houses of Parliament by Command of Her Majesty.
August 1882.

LONDON:
PRINTED BY HARRISON AND SONS.
1882.

[The Specimens alluded to in this Report are exhibited in No. 1 Museum, in the Royal Gardens at Kew.]

Report by Her Majesty's Acting Consul at Hakodate on the Lacquer Industry of Japan.

Tôkiô, January 13, 1882.

THE following Report is intended chiefly as a description of the articles of various kinds illustrative of the lacquer industry of Japan, collected for the use of the Museum of Economic Botany at Kew, under instructions from Her Majesty's Chargé d'Affaires at Tôkiô.

While preparing it, it was found that a number of Japanese terms had to be employed, which without a somewhat detailed explanation would be unintelligible to any one not acquainted with the Japanese language and not familiar with the technicalities of the lacquer trade. A short description of the various processes through which lacquer passes, from the planting of the tree to the completion of the decoration in various styles, has therefore been given, but all historical and other details not specially called for have been omitted.

I have considered it advisable to make each step a progressive one, detailing the various processes as nearly as possible in the order in which they follow each other in actual practice, together with the materials and implements employed.

Thus, after describing the cultivation of the lacquer tree, a list of the tools used for tapping is given, followed by a description of the method pursued by the tappers, and so on.

The headings under which the subject-matter divides itself are as follows :—

1. Cultivation of the lacquer tree.
2. Tools used in tapping.
3. Mode of tapping and treating the tree.
4. Various woods used in making lacquer ware.
5. Various kinds of lacquer and mixtures used—

 (*a.*) For plain work.
 (*b.*) For lacquering with gold.

6. Implements and materials used in the manufacture of plain lacquer.
7. Mode of applying the lacquer in making—

 (*a.*) *Hon-ji* (real basis).
 (*b.*) *Kata-ji* (hard basis).
 (*c.*) *Han-dan-ji* (half-step basis).
 (*d.*) *Manzo,* so called after a lacquer worker of that name.
 (*e.*) *Ka-no-ji* (inferior basis).
 (*f.*) *Shibu-ji* (Persimmon)—(juice basis).
 (*g.*) *Sabi-sabi* (double sabi).
 (*h.*) *Kaki-awase* (mixture), or *Kuro-shunkei* (black Shunkei), from the name of its inventor.
 (*i.*) *Aka-shunkei* (red Shunkei).
 (*j.*) *Kijiro* (colour of the grain of wood).
 (*k.*) *Red* and *coloured* lacquers.

B 2

8. Tools and materials used in the manufacture of gold lacquer.
9. Mode of making gold lacquer—
 (*a.*) *Togi-dashi* (bringing out by grinding).
 (*b.*) *Hira-makiye* (flat gold lacquer).
 (*c.*) *Taka-makiye* (raised gold lacquer).
 (*d.*) Lacquering on metal.

Accompanying these notes is a short paper on the subject of lacquer, read at a meeting of the Asiatic Society of Japan on the 12th October, 1880, which may prove of some interest, as containing a few historical and other details here left unmentioned.

The present investigations have shown that certain statements therein made must be modified, so that where the description of any process differs —especially that relating to the tapping of the trees—the present paper must be taken as the correct one.

Great difficulty has been experienced in obtaining thoroughly reliable information, as not only are the artificers, for the most part, uneducated, ut they are entirely ignorant of what takes place in any other department except that to which they have been brought up. A well-known and most intelligent manufacturer, Takei Tōsuke, who has been over twenty years himself a worker in gold lacquer, and from whom great assistance has been derived in bringing together the present collection, was quite unaware of the mode of tapping and treating the trees, and had never even seen a cut specimen of the wood until the pieces now forwarded were procured. He states that his head workman, a highly-skilled artizan over 50 years of age, hardly knows the name of a single article that he uses. Having, however, communicated direct with the persons who conduct the several branches, it is hoped the following pages will contain no inaccuracies.

The *Rhus vernicifera*, the well-known lacquer tree of Japan, is met with all over the main island, and also in smaller quantities in Kiushiu and Shikoku, but it is from Tōkiô northwards that it principally flourishes, growing freely on mountains as well as in the plains, thus indicating that a moderate climate suits the tree better than a very warm one. Since early days the cultivation of the tree has been encouraged by the Government, and as the lacquer industry increased plantations were made in every province and district. The lacquer tree can be propagated by seed sown at the end of January or the beginning of February. The first year the seedlings reach a height of from 10 inches to 1 foot. The following spring the young trees are transplanted about 6 feet apart, and in ten years an average tree should be 10 feet high, the diameter of its trunk $2\frac{1}{2}$ to 3 inches, and its yield of lacquer sufficient to fill a 3-ounce bottle.

A more speedy method is, however, generally adopted. The roots of a vigorous young tree are taken, and pieces 6 inches long and the thickness of a finger are planted out in a slanting direction a few inches apart, 1 inch being left exposed above the ground. This takes place in the end of February and through March, according to the climate of the locality. These cuttings throw a strong shoot of from 18 to 20 inches the first year, and are likewise planted out the following spring. Under equally favourable circumstances these trees would in ten years be nearly 25 per cent. larger in girth, some 2 or 3 feet higher, and would yield nearly half as much more sap than the trees raised from seed.

It has not hitherto been the custom to bestow any special care on the trees after planting them out, but in cases where leaf or other manure has been applied they are much finer. Of late years hill sides and waste grounds alone have been used for lacquer plantations, as, owing to the rise in the price of cereals and farm produce generally, it does not pay the farmers

THE QUIN REPORT

1. *Kawa-muki.* Bark parer.
2. *Yeda-gama.* Branch sickle.
3. *Kaki-gama.* Scraping sickle.
4. *Yeguri.* Gouge.
5. *Natsu-bera.* Summer spatula.
6. *Hōchō.* Knife.
7. *Seshime-bera. Seshime* spatula.
9. *Gō-guri.* Pot gouge.

The numbers and descriptions are those given in Quin's catalogue at the end of this report (see page 79).

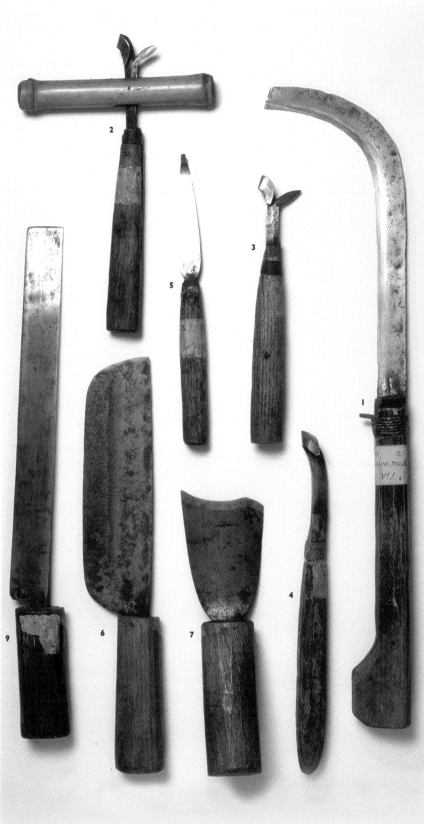

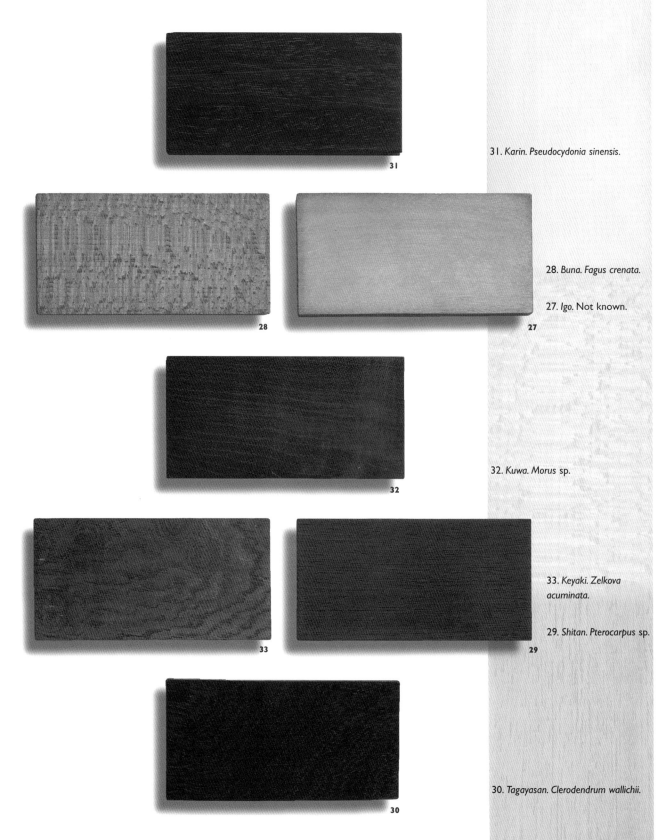

31. *Karin. Pseudocydonia sinensis.*

28. *Buna. Fagus crenata.*

27. *Igo.* Not known.

32. *Kuwa. Morus* sp.

33. *Keyaki. Zelkova acuminata.*

29. *Shitan. Pterocarpus* sp.

30. *Tagayasan. Clerodendrum wallichii.*

REPORT ON LACQUER INDUSTRY.

to have their land cumbered with trees. Those that have been hitherto planted along the borders of the fields are being rapidly used and uprooted, and, where practicable, mulberry trees are planted instead, with a view to rearing silkworms. Nevertheless, as a good workman is expected during the season to tap an average of 1,000 trees ten years old, and as the Province of Yechizen alone sends out about 1,500 "tappers" yearly to the various lacquer districts, it will be seen that an immense production annually takes place, stimulated, doubtless, by the demand for cheap lacquered articles abroad.

It should also be mentioned that to remedy the possible exhaustion of the supply, and in view of the great rise which has taken place in the price of lacquer, several Companies are being projected to plant waste lands with the tree. A ten-year-old tree, which some five years ago only cost from 1 to 2 sen, now costs 10 sen, which, allowing even for the depreciation in the value of the paper currency, shows a rise of about 500 per cent.

The best transparent lacquer comes from the districts of Tsugaru, Nambu, Akita, and Aidzu. It is largely used by the workers of Kioto, Osaka, and the southern provinces, but though also used in Tôkiô is not so much appreciated there as the lacquer produced from the neighbourhood of Chichibu in the Province of Mus-ashi, from Nikko in Shimotsuke, and that produced in the Provinces of Kōdzuke and Sagami, which hardens more rapidly, and is best for black lacquer.

There are some districts the lacquer obtained from which is best for certain kinds of work, but is not so well adapted for others. The kind which is used for transparent lacquer is mixed in large tubs, to insure a uniform quality, and being allowed to stand for some time (say, a week or ten days), the best portion, which is ordinarily 70 per cent. of the whole, is skimmed off. This is used for *Nashiji* and *Shu* lacquer, while the remainder is used for making inferior mixtures, such as *Jōhana*, &c., all described elsewhere. Almost all the various classes of lacquer are similarly dealt with to insure uniformity, as some qualities dry much quicker and are better than others, and the slow-drying qualities would otherwise remain unsold.

The whole country produces at present on an average from 30,000 to 35,000 tubs per annum, each tub being of about four gallons capacity. Some 70 to 80 per cent. of this total amount is produced from Tôkiô northwards. Nearly one-half of the lacquer produced is sent to the Osaka market, where it is prepared as required and resold all over the western and southern provinces, the remaining portion being used up locally and in Tôkiô.

The usual age at which a tree is tapped is ten years, but in some few cases a tree is tapped when only three or four years old. The best lacquer for transparent varnish is obtained from trees from one to two hundred years old, as their sap has more body, and is more glutinous. The tools used in obtaining the lacquer are as follows:—

Kawa-muki (bark parer), a curved knife with which the workman smoothes all inequalities of the bark before tapping the tree.

Yeda-gama (branch sickle), an instrument with a gouge on one side and a knife on the other, fitted with a piece of bamboo to give the hand a good hold when tapping branches.

Kaki-gama (scraping sickle), a similar instrument, without the piece of bamboo used for tapping trees generally.

Yeguri (a gouge), used in autumn to scrape the bark smooth before giving the final cut with the *kaki-gama*.

Natsu-bera (summer spatula), used for scraping the sap out of the incisions into the receptacle named *gō*.

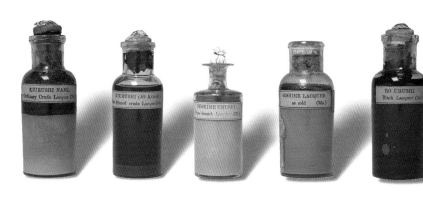

34. *Ki-urushi* (*nami*). Ordinary crude lacquer.

34 A. *Ki-urushi* (*Jō-koshi*). Best filtered lacquer.

35. *Seshime-urushi*. Pure branch lacquer.

35 A. *Seshime*. Lacquer as sold.

36. *Rō urushi*. Black lacquer.

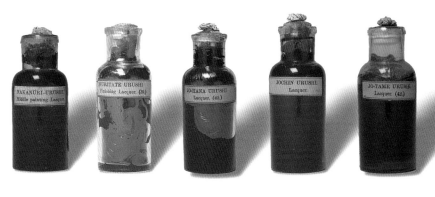

38. *Nakanuri-urushi*. Middle painting lacquer.

39. *Nuritate-urushi*. Finishing lacquer.

40. *Jō-hana-urushi*.

41. *Jō-chiu-urushi*.

42. *Jo-tame-urushi*.

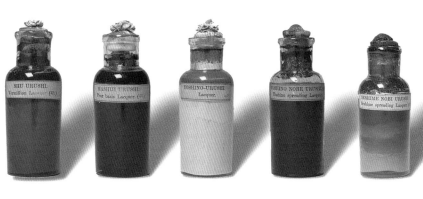

43. *Shu-urushi*. Vermilion lacquer.

44. *Nashiji-urushi*. Pear-basis lacquer.

45. *Yoshino-urushi*.

46. *Yoshino-nobe-urushi*. Yoshino spreading lacquer.

47. *Seshime-urushi*. Seshime spreading lacquer.

48. *Shitamaki-urushi*. Under-coat lacquer.

49. Not illustrated.

50. *Shitamaki-nobe-urushi*. Under-coat spreading lacquer.

51. *Takamaki-urushi*. Raised lacquer.

52. *Rō-sé-urushi*. Mixture of branch and black lacquer.

53. *Kenna*. Black liquid.

Hōchō (knife), used for cutting the bark of branches in obtaining *seshime* or branch lacquer.

Seshime-bera (seshime spatula), used for collecting the sap which exudes from the incisions in the bark of the branches.

Gō, the bamboo or wooden pot, in which the sap is put as it is collected.

Gō-guri (pot gouge), a long straight knife for scraping the lacquer out of the pot into the tub.

Te-bukuro (glove), worn by the tapper to protect his hand from contact with the sap.

The first tapping takes place about the beginning of June. The standard number of trees allotted to a tapper for the season is 1,000—presuming them to be about ten years old (the size of the small specimen), about 800 of the size of the large specimen, and so on, less and less according to the size of the trees. Having cleared away the grass from the roots, the workman makes the round of his allotted trees, marking each with small notches about half an inch long. The first of these notches is made about six inches from the bottom of the tree on the right-hand side; the next, one "hand stretch" higher up on the left-hand side; the next, one "hand stretch" higher on the right, and so on, alternately as far as the workman can reach. These preliminary markings, which are to determine all the places for subsequent tapping, take fully four days, being at the rate of 250 trees a-day. The tapper then goes round, provided with the bark scraper, the ordinary scraping sickle, the summer spatula, and the pot to hold the lacquer, and first smoothing the bark where required gives one cut above and one cut below the two lower marks, and one cut above the remainder of the other marks, the cut being in each case about an inch and a-half long. After giving the cut the instrument is reversed, and the knife is run along the incision to insure the bark being entirely cut through. This process is repeated every four days, each incision being made a little longer than the preceding one, up to the fifth tapping, inclusive, after which the remaining incisions are made of the same length. At each round, when all the requisite incisions have been made on the tree, the workman gathers the sap which has exuded with the spatula, beginning with the two lowest incisions, and so on to the uppermost cut. Twenty-five is considered the normal number of cuts, which, at the rate of one incision at each place every four days, occupy 100 working days, and allowing for some twenty days of rain during which the sap cannot be drawn, the season is brought to a close by the end of September. If the workman has any large trees to tap, the whole of which he cannot reach when making his ordinary rounds, he taps all he can reach, and when his round is concluded he returns with a ladder, and mounting each tree taps the remainder of the trunk and the leading limbs in the same manner as above described, previous to making a fresh round.

When the full number of incisions has been given, the workman gives an extra long cut underneath all the initial notches on each tree to obtain the sap which has collected there, and another above the uppermost cut of each set. These incisions are called *Ura-me* (back marks). The workman also makes a number of cuts, each about a foot apart, in all the branches whose diameter exceeds one inch. This operation requires about sixteen days to get through the whole number of trees. The next operation is called *Tomé* (the finish). This consists in a number of incisions completely encircling the tree wherever the workman perceives a likely place. The next process consists in cutting off all the branches: the larger ones are once more tapped after being cut off to extract any sap that may still remain in them, and the small branches which have not

REPORT ON LACQUER INDUSTRY.

yet been tapped are tied in bundles and steeped in water for about ten days. When taken out and dried the bark is cut with a knife, and the sap which exudes is collected with the branch spatula, and is called *Seshime* lacquer. This word seems to be derived from *Sehi*, the name of a machine, and *shimeru* (to press), from a practice which obtained in olden days of pressing the branches in such a machine to obtain the sap. It is also known as *Yeda urushi*, or branch lacquer, which latter more explicit term is, for the sake of convenience, used throughout this Report.

The sap obtained from the first five cuts above each notch is poor, containing, as it does, a large proportion of water; the middle fifteen cuts produce the best sap, and the sap obtained from the last five incisions is poor, and lacks consistency. Again, the sap obtained from the *Ura-me* (back marks) and *Tomé* (finishing) cuts is very good, and dries quickly.

The sap from the first twenty-five cuts is mixed and sold together, but the *Ura me* and *Tomé* sap is almost always mixed and sold separately. The operations above described kills the tree in one season, but frequently the tree is made to last two years or more, by giving only half the number of incisions, and reserving the *Ura-me* and *Tomé* cuts for the final year. The sap obtained the second and following years is, however, of an inferior quality, and this method is only resorted to by private individuals, who tap their own trees during the intervals of farming. Ordinarily, a wholesale dealer in lacquer buys so many thousand trees from the owner, and, as a matter of course, extracts the sap with as little delay as possible, making a contract for the purpose with professional tappers. A first-rate workman will receive over 100 yen (equal, at the present low rate of exchange, to nearly 13l. sterling) for the season, and can collect four and-a-half tubs (equivalent to eighteen gallons), but the average receive 75 yen, and collect proportionately less. The present price per tub of lacquer ranges from 90 to 100 yen.

After the sap has been taken the exhausted tree, which remains the property of the seller, is cut down by him, and is used for firewood, for building purposes, or for making boxes. The roots of the young trees throw from three to five shoots the following spring, and these can be used in six or seven years. Of these five sprouts three are commonly much stronger than the other two. In such cases, the strong ones only are tapped and cut down, the weaker ones being allowed a year or two longer to grow, when, receiving the whole of the nutriment, they shoot up in one year as much as an ordinary tree would in three. After tapping and cutting down fresh shoots to the number of five are again allowed to sprout, and so on, the root not seeming to become exhausted by the process; but when a very old tree is cut down the root will not give out new shoots. In the northern provinces very old and large trees are met with in considerable quantities. These were kept for the sake of their berries, from which the wax used for the Japanese candles were obtained. This was the more profitable use to which to put the tree, as a good tree, from 80 to 100 years old, yielded yearly, on an average, equal to 6s., while the price of a ten-year-old tree to be used for extracting the sap was under $\frac{1}{2}d$. Previous to the Revolution of 1868 every tree reserved for making wax was officially registered, and the owner was not allowed to mutilate it in any way. Even if a tree died, he had to get official permission before removing the stump. The Shōgun's Government and also the local magnates had large plantations of the lacquer tree reserved for wax, but since the opening of the country to foreign trade, and the introduction from abroad of kerosene oil, the wax industry has greatly declined, and there are now no restrictions on the free sale of the tree for tapping, and, consequently, all the fine old trees (which will sell for from 5 to 6 yen each) are fast disappearing.

54. *Hera*. Spatula made of *hinoki*.

113. *Kujira-bera*. Whalebone spatula.

114. *Hera*. Spatulas of *hinoki*. Used for lacquer and *sabi*.

65. *Awo-to-ishi*. Green whetstone.

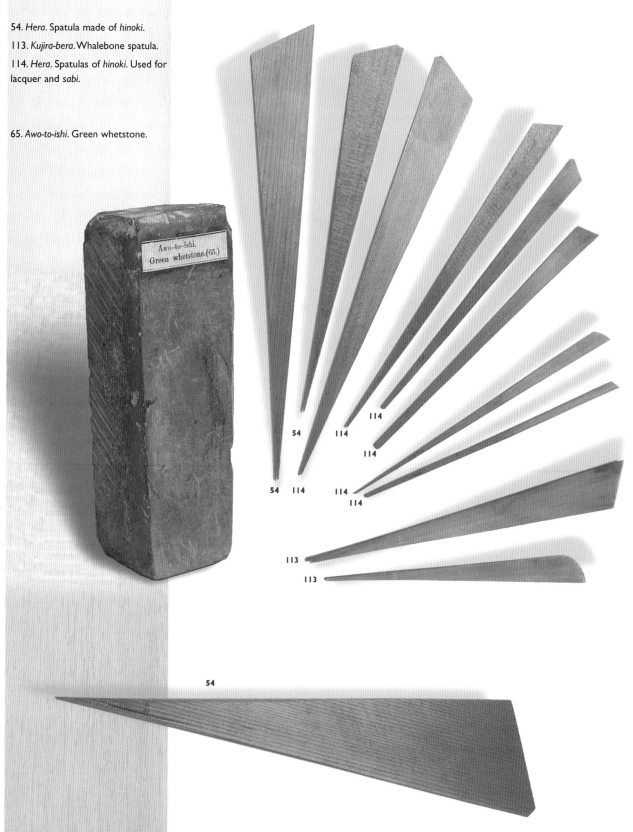

LACQUER LEGACY

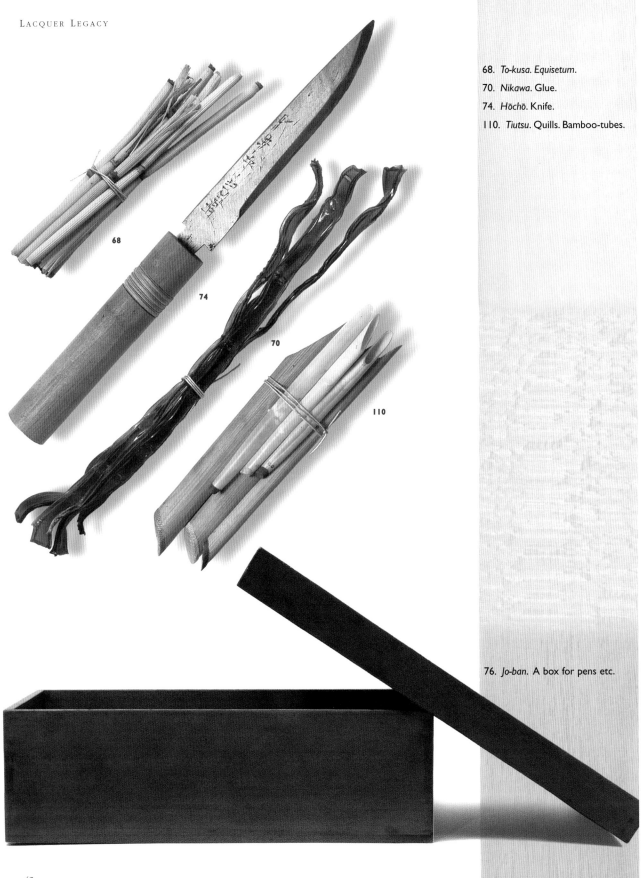

68. *To-kusa.* Equisetum.
70. *Nikawa.* Glue.
74. *Hōchō.* Knife.
110. *Tiutsu.* Quills. Bamboo-tubes.

76. *Jo-ban.* A box for pens etc.

JAPAN.

To show the relative value of the berries and the trees a few years ago the following may be cited:—A wholesale lacquer merchant informed me that five or six years ago he went as usual to purchase trees in the district of Aidzu, and among others bought one tree for a yen (then equal to 4s.), the owner reserving the berries that might be got as his own property. He does not consider the bargain was a cheap one, but the owner realized the sum of 80 sen (equal to 3s. 2d.) from that year's yield of the berries alone before cutting down the tree.

It should be mentioned that the above description of the method pursued in tapping the lacquer tree is that which is recognized as the proper one; but, as even the specimens of the lacquer tree forwarded will show, the rule is not rigidly observed, the style and size of the tree, and the caprice of the workman, combining to cause variations in the number of incisions given in each series.

Various Woods used in making Lacquer Ware.

The woods chosen for lacquering on are naturally selected according to the use to which the lacquered article is to be put. For shelves, cabinets, and boxes of all kinds, the following are principally used, and are set down in the order of their excellence:—

Hinoki (Chamæcyparis obtusa).—This is by far the best wood for making boxes, as it does not warp.

Kiri (Paulownia imperialis).—A light wood, used for clothes boxes, which are only lacquered on the outside. It is also used for making tea-caddies, as the wood has no smell.

Hōno-ki (Magnolia hypolema).—All sword sheaths have hitherto been made of this wood.

Sawara (Chamæcyparis pisifera).—This is a wood of a coarser grain than *Hinoki (Ch. obtusa).*

Hime-ko-matsu.—This wood is used for carved figures of men, animals, &c. It is not liable to split and crack.

Tsuga (Abies tsuga).

Hiba (Thujopsis dolabrata).—Used for making cheap articles.

Akamatsu (Pinus densiflora).

Sugi (Cryptomeria japonica).—This wood is only used in making the cheapest and most inferior goods.

The following woods are mostly used in the manufacture of such articles as are turned in a lathe, as bowls, rice cups, round trays, &c.:

Keyaki (Planera japonica), the best being obtained from the Province of Hiuga.

Shoji.

Sakura (Prunus pseudo-Cerasus).

Katsura (Cercidiphyllum japonicum).

Tchō (Ginko biloba).

I-go.—Grown in large quantities in the neighbourhood of Hakone. It is principally used in the manufacture of toys and cheap articles.

Buna.—Principally used in the district of Aidzu for the same kind of utensils as *Keyaki* and *Sakura*, but being a brittle wood, it cannot be turned in a lathe to make such fine articles; those made of this wood are coarser and heavier. For raised gold lacquering over the unvarnished surface, the following hard ornamental woods are often used:—

Shitan.

Tagayasan.

Karin (quince).

Kuwa (mulberry).

Keyaki (Planera japonica).—Ornamental grain.

Magnolia hypolema is a misprint of Magnolia hypoleuca.

REPORT ON LACQUER INDUSTRY.

Various Kinds of Lacquer and Mixtures used.

(a.) For Plain Work.

Ki-urushi (crude lacquer) is the generic name by which all lacquer obtained from the trunks of live trees is known. It forms the basis of nearly all the various mixtures used in making lacquer ware.

Seshime (branch lacquer).—This kind is obtained from the branches of the trees, as described above; but the yield is only about 1 per cent. in comparison with other lacquer. As, however, in working the proportion of nearly 90 per cent. is required, the lacquer manufacturers sell a mixture, which is stated to be a compound of true branch lacquer, the best crude lacquer, *Ura-me* and *Tomé* lacquer, *funori* (seaweed jelly), sweet potatoes grated fine, the whole coloured, as may be necessary, with soot. The proportions in which these materials are used cannot be ascertained, and, indeed, each manufacturer uses his own special mixture, but the extraneous additions are believed not to injure the quality of the whole.

True branch lacquer becomes extremely hard when once dry, but used alone will not dry under some twenty days, so that now, when time is an object, the pure sap is but little used. Previous to the Revolution of 1868 branch lacquer of a very superior quality, and which would dry quickly, was obtained by using the young shoots which sprouted yearly from the roots after the trees had been cut down. This kind was called *Ki-seshime* (crude branch lacquer), and was made under directions from the Government, who received it as taxes; but the practice has been discontinued of late. The price of pure branch lacquer is—owing to the difficulty in drying—only 70 per cent. of ordinary good lacquer.

Rō-urushi (black lacquer).—This is made by adding to crude or branch lacquer about 5 per cent. of the tooth-dye used by women (*Haguro*), a liquor formed by boiling iron filings in rice vinegar, and exposing it to the sun for several days, stirring the mixture frequently till it becomes a deep black.

In preparing all lacquer—from the crude lacquer to the various mixtures—the principal object is to get rid of the water that exudes from the tree with the sap. To effect this, it is exposed in broad flat wooden dishes, and stirred in the sun. This, however, alone will not cause the original water to evaporate, so from time to time—ordinarily about three times in the day—a small portion of clean water is stirred in, say, 1 per cent. each time, for a couple or three days, according to the heat of the sun. All the water then evaporates together. No lacquer will dry until this process has been gone through. If the lacquer is old, *i.e.*, has been tapped a long time before using, it is much more difficult to dry. In such cases a portion of fresh lacquer is added to the old by the wholesale dealers, or else the manufacturers, instead of water, sometimes mix *saké* (rice beer) or alcohol, to "quicken" it.

A very remarkable property of lacquer should be mentioned. If crude lacquer, which is originally of the colour and consistency of cream, is exposed to the sun for a few days without adding water, it loses its creamy colour, and becomes quite black, or nearly so, but also becomes thinner and transparent, or rather translucent, as can be seen when it is smeared on a white board. It will not now, however, dry if applied to an article, even if kept a month or more in the damp press. But if water is mixed with the lacquer which has thus been exposed and become black it at once loses the black colour and its transparency, and becomes again of a creamy colour, though slightly darker, as if some coffee had been added, than at first. After evaporating this water, it can then be used like any ordinary lacquer, either alone or in mixtures, and will dry in the damp

THE QUIN REPORT

78. *Muro.* Drying-press.

82. (*d.*) *Manzo.* Class IV.
88. (*j.*) *Kijiro.* Colour of the grain of wood.

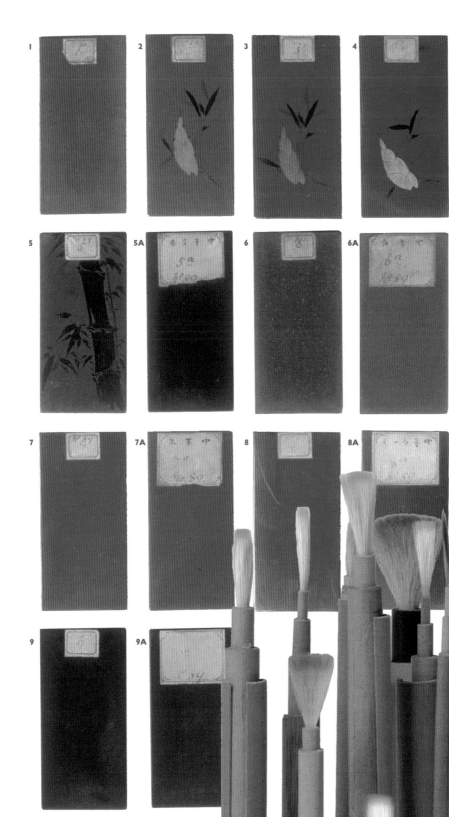

89. (k.) Red and coloured lacquers.

1. Coating of red lacquer ground down with magnolia charcoal.

2. Pattern applied in black lacquer and gold.

3. Coating of transparent lacquer applied.

4. Finally polished.

5. Best. 5 A. Second best.

6. " 6 A. "

7. " 7 A. "

8. " 8 A. "

9. " 9 A. "

The same colours being used.

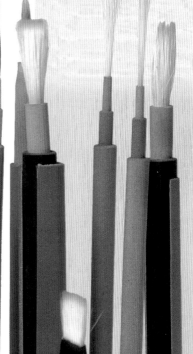

99. *U-no-ke-usuji-fude*. Fine brushes made of hare's hair.

100. *Ji-nuri-fude*. Grounding brushes of hare's hair. Five sizes.

101. *U-no-ke-hake*. Flat brush of hare's hair.

102. *Mensō*. Stiff brush of deer's hair.

press, during which process it again turns black. What lacquer workers have found their greatest stumbling-block is the difficulty of obtaining a clear transparent varnish. What is called transparent varnish is really black to the eye, and requires grinding and polishing after application before it presents a brilliant surface, becoming also much lighter after a little time. It would be a new era in the manufacture of lacquer ware if a method could be discovered of rendering the lacquer varnish perfectly clear and light coloured when so desired, without depriving it of its drying qualities, and also if colours could be used with it other than those hereafter mentioned.

Nakanuri-urushi (middle painting varnish).—This is merely the crude lacquer. After having been exposed for some time to the sun to darken it and to get rid of all water, it is used for under-coats in making first-class lacquer ware.

Nuritate-urushi (finishing lacquer).— This is a mixture of crude lacquer and a little turpentine with *Tō-midzu* (whetstone water)—being the mixture obtained from whetstones on which blades have been sharpened. In it there is some 7 to 8 per cent. of iron, and after mixing the whole is exposed to the sun, both for the purpose of getting rid of all the water and to darken the colour. This is used for final coats of cheap lacquer, which is not polished afterwards.

Jō-hana-urushi.—This is a mixture of the above kind, with oil obtained from the *Ye* plant (*Perilla ocymoides*). This is used for still more common kinds, requiring no after polishing, and the lacquer does not present a hard surface.

Jō-chiu, called in Kioto *Chiu-hana*; *Jō-tame*, called in Kioto *Ge-hana*.

These contain more and more oil, and are used for the commonest articles, such as for varnishing clogs, clothes baskets, &c. These three last kinds give a high polish, but the lacquer does not last.

Shu-urushi (vermilion lacquer).—This is the best crude or transparent varnish mixed with *Ye* oil (*Perilla ocymoides*), sometimes as much as 50 per cent. being added. It is then exposed to the sun and water added, which is afterwards evaporated. This kind is only used for red (whence its name) and coloured lacquers, the colours being added at the time of application. It requires no after polishing.

(b.) *For Lacquering with Gold.*

Nashiji-urushi (pear basis lacquer), or *Suki-urushi* (transparent lacquer).—The first name is that best known in the trade, as indicating that it is required for using over gold, silver, or tin powdering. It consists of the finest crude lacquer obtained from old trees. As stated previously, the lacquer is allowed to stand till all dirt and foreign matter has sunk to the bottom, when the best is skimmed off, and after being exposed to the sun to evaporate the water in the usual manner, and carefully filtered, it is ready for use. Except when used for the highest class of gold powdering, a certain proportion of gamboge is mixed with the lacquer to give the dust a fine yellow colour.

N.B.—The above ten kinds are all bought by the lacquer workers ready prepared from the manufacturers. Any further mixtures used by them are made as required, colours added, &c.

Seshime-urushi (branch lacquer) and *Rō-urushi* are used also in making gold lacquer.

Yoshino-urushi.—This is crude lacquer from the district of Yoshino in the Province of Yamato. It dries quickly, and closely resembles transparent varnish. It is used when giving the final coats before polishing.

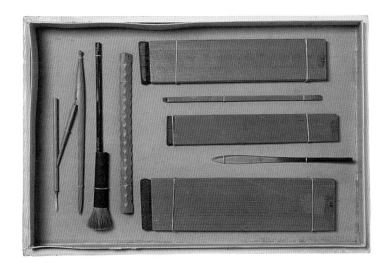

55. *Hake*. Flat brush made from human hair.

104. *Bun-mawashi*. Compass, with brush attached.

105. *Kébō*. Brushes made of horsehair.

107. *Fude-arai*. Brush-cleaner.

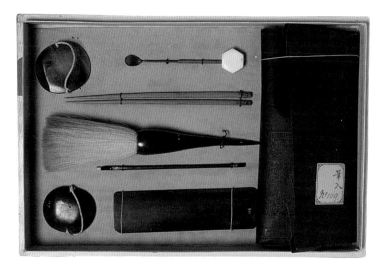

109. *Fude-ire*. Brush-case.

111. *Saji*. Spoon.

112. *Hirame-fude*. Used in affixing *hirame*, &c.

115. The tooth of a fish. Used for polishing.

116. A piece of polished shell. Used for smoothing paper.

117. *Tsume-ban*. Palette.

118. *Take-ban*. Small bamboo board.

119. *Fun-bako*. Flat lacquered box, for holding gold-dust.

Yoshino-nobe-urushi (Yoshino spreading lacquer).—Same as above, with the addition of about one-third of camphor to render the lacquer thinner and more easy to spread.

Seshime-nobe-urushi (spreading branch lacquer).—This is merely branch lacquer with the same proportion of camphor as above when cheap work is required; more camphor is used till the proportions are reversed. This renders the mixture very soft, and a small quantity can be spread over a large surface.

Shita-maki-urushi (under coat lacquer)—A mixture of branch lacquer and *Benigara* (red oxide of iron) in equal parts by weight.

Ke-uchi-urushi (inside line lacquer).—This is the same as above, but it is allowed to stand for about six months after mixing before it is used. By this time it has got thicker, and the very finest lines can be drawn without fear of their running, and they moreover stand out better.

Shita-maki-nobe-urushi (under coat spreading lacquer).—Same composition as above, with the addition of a little camphor to make the lacquer thin. It thus goes much farther, and causes a great saving when lacquering with powdered gold-leaf (*keshi-fun*), for which it is best suited. As in the other mixtures, the more camphor is used the thinner it renders the lacquer, and the less gold is required.

Taka-maki-urushi (raised lacquer).—To make this a certain quantity of *Rō* or *Nuritate* is taken and divided into three parts. To one part is added lampblack and camphor in equal portions of bulk. These, after being well mixed, are boiled together; then the other two portions are added, and the whole stirred together, and afterwards filtered through paper. It is boiled more or less according to the season. In summer, when lacquer dries quickly, it is boiled for a longer period, while in winter, or during cold weather, when lacquer naturally takes longer to dry, the mixture is boiled for a shorter time. The reason why *Takamaki* is thus purposely rendered soft is explained by the fact that otherwise the upper surface would harden at once, while the under portion (*Takamaki* being applied thickly), being excluded from the upper air, would not be able to dry, and later the top surface would crack and show fissures, whereas the introduction of camphor renders it soft and much slower to dry, and the whole has thus time to harden equally. Camphor being volatile is gradually lost, and the composition becomes quite hard.

Ro-se-urushi (a mixture of black and branch lacquer).—This is used for the lacquer coating upon which gold, silver, or tin powder is scattered, except in such cases when the grain of the wood is to be shown, when *nashiji* lacquer is used instead.

Kuma-urushi (shading lacquer).—A mixture of *Johana* lacquer and lampblack, used for final shading in the feathers of birds or animals, or for drawing hair, &c., on flat and raised gold lacquer.

It should be noted that whenever lampblack is mentioned as a mixture it is used for the superior kinds, wood or coal soot being used for inferior articles.

Implements and Materials used in the Manufacture of Plain Lacquered Ware.

Hera.—A spatula made of *Hinoki* (*Chamæcyparis obtusa*), used for applying the under or priming coats and for mixing the lacquer.

Haké.—A flat brush made from human hair, used for laying on the lacquer.

Kokuso.—Finely chopped hemp. Mixed with lacquer it is used for covering joints.

Nuno.—Hempen cloth, used for pasting over the wood to prevent it

JAPAN.

splitting and to strengthen corners, &c. For very fine work and small articles silk is used.

Ji-no-ko (burnt clay).—Afterwards reduced to a very fine powder. Pounded bricks are often used.

To-no-ko.—A fine kind of clay, which is procured from Mount Mari, near Kioto. This is likewise burnt, and reduced to a fine powder.

Sumi.—Charcoal made of *Hōnoki* (*Magnolia hypoleuca*), used for smoothing down the under coats; it has rather a rough grain. Also charcoal made from *Hiyakujikkō* (*Largerstramia indica*). This is very soft and of a fine grain, and is used for the final smoothing before hand polishing. This kind is called by the trade *Rō-iro-sumi* (black coloured charcoal).

To-ishi.—Whetstones of four different qualities of fineness: *Ara-to* (rough), *shiro-to* (white), *awo-to* (green), and *nagura*, the last being the finest. These are used for smoothing down the priming coats.

Tsuno-ko (horn powder).—This is made of calcined deer's-horns, reduced to a fine powder, and is used for the final polishing with the finger.

To-kusa equisetum.—A kind of scouring rush, used for smoothing the lacquer.

Kaki-no-shibu (Persimmon juice).—This is used when no ground lacquer is required, as in the Aidzu lacquer, or when the grain of the wood is shown.

Nikawa (glue).—This is used to mix with the groundwork for cheap kinds of ware, instead of lacquer.

Yuyen-sumi (lampblack).—Used for groundwork of cheap articles, mixed with Persimmon juice. For still more common ware, soot of any kind is used.

Gofun (whiting).—Made from burning old shells, such as are obtained from the ancient kitchen middens; used for mixing with glue to make the groundwork of common lacquer.

Shō-no (camphor).—Used for mixing with lacquer, to make it thinner and spread more easily.

Hōchō (knife).—Used for scraping off all inequalities of the hempen cloth after it is pasted on the article, &c.

Yoshino-gami.—A very thin kind of paper, made at Yoshino; used for filtering the lacquer before using it.

Jō-ban.—A box with a very hard lacquered lid, usually containing drawers for the various pencils, &c. The lid is used for mixing the lacquer on while working.

Tsuno-ko-ban.—Board for mixing and powdering the deer's-horn ashes before using; generally made of cherry wood or oak.

Muro.—A cave or cellar underground is used, where practicable; otherwise, an air-tight case, made of wood, with rough unplaned planks inside. These are thoroughly wetted before the lacquered article is put in to dry, which occupies a period varying from six to fifty hours, according to the time of the year or style of the lacquer. Lacquer will not dry or harden properly in the open air; it absolutely requires a damp closed atmosphere to do so, otherwise it would run and always remain sticky.

The following are mixtures made by the workman as required. None of these mixtures are forwarded, as the articles forming them are sent separately, and the proportions in which they are used are detailed in each case:—

Kokuso.—A mixture of finely-chopped hemp, with rice starch and branch lacquer sufficient to make a thick paste.

Jino-ko (No. 1).—Powdered burnt clay and branch lacquer, mixed together in the proportion one part of clay to two parts of lacquer.

123. Specimen board, containing 110 samples of *yasuri-ko, hirame, nashiji* and sundry colours, &c.

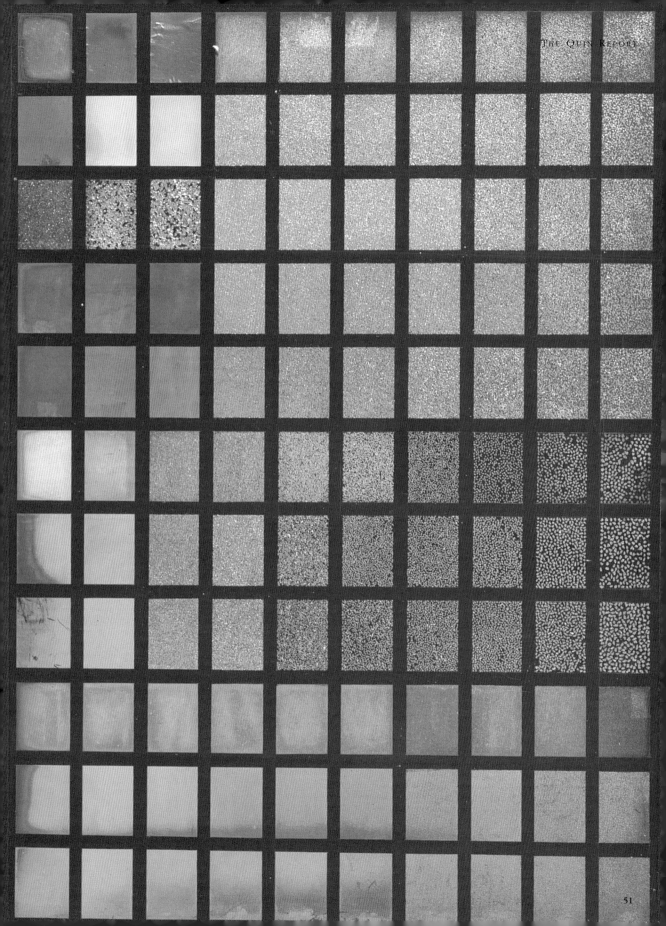

REPORT ON LACQUER INDUSTRY. 11

Jino-ko (No. 2).—The same, mixed in the proportion of ten parts of clay to thirteen of lacquer, and a little water.

Jino-ko (No. 3).—The same, mixed in the proportion of ten parts of clay to eight parts of lacquer and two parts of thin rice starch. This mixture is known in the trade as *Han-dan-ji* (half-step basis).

Jino-ko (No. 4).—The burnt clay powder mixed with liquid glue only in such proportions as will resemble the consistency of lacquer.

Kiri-ko.—A mixture of *Jino-ko* and *Tōno-ko* in equal portions with one and a-half of branch lacquer. This becomes very hard.

Sabi —A mixture of two parts of the burnt clay from Mount Mari to one and a-half of branch lacquer, with just sufficient water to mix the clay into a paste.

An inferior class of *Sabi* is made by putting in less lacquer—as little as eight parts of lacquer being used to twenty parts of the clay. Less lacquer cannot be used, as it would not stand polishing after having been dried.

Mugi-urushi.—Wheat lacquer; being a portion of wheaten flour mixed with branch lacquer to such consistency as may be required. It is used to paste the hempen cloth on to the wood.

Shin.—A mixture of rice flour with branch lacquer, used for the same purpose as wheat lacquer. Wheaten flour is the best, but being more difficult to blend with lacquer it is not so much used.

Ka-no-ji.—A mixture of whiting and liquid glue, used for under coats or cheap articles.

Shibu-ji.—A mixture of lampblack and Persimmon juice, used for under coats in inferior ware.

Mode of applying the lacquer in making—

(a.) *Honji* (real basis). Class I.

1. The article to be lacquered is first carefully smoothed.
2. The wood is slightly hollowed away along each joint, so as to form a circular depression.
3. The surface of the whole article is then given a coating of branch lacquer (this is called *Ki-ji-gatame*—hardening the wooden basis), and the article set to dry in the damp press, or *Muro*, for about twelve hours.
4. The hollowed portions are filled with prepared *Kokuso*, which is well rubbed in with a spatula made of the wood of the *Chamæcyparis obtusa*, and the article is inclosed in the drying press for a period of at least forty hours.
5. Over the *Kokuso* a coating of *Sabi* is applied, and set to dry for twelve hours.
6. The next process is to smooth off with a white whetstone any roughness or inequalities of the *Kokuso* and *Sabi*.
7. The article is then given a coating of wheaten lacquer, over which is stretched hempen cloth, great care being taken to spread it smoothly and leave no wrinkles or perceptible joinings, and it is then again inclosed in the drying press for about twenty-four hours.
8. After taking the article out of the press all inequalities in the cloth —which has now under the influence of the lacquer become harder than wood—are smoothed down with a knife or with a plane.
9. Next, a coating of *Sabi* is applied with the spatula, to hide the texture of the hempen cloth, and the article is again put in the press for twenty-four hours.
10. Next, a coating is given of No. 1, *Jino-ko*, applied with the spatula, after which the article is inclosed in the drying press for twenty-four hours.
11 and 12 are repetitions of the same process.

127. Specimen of *togi-dashi*. Water and clouds — 1 to 3. Outline, veining and powdering with *yasuri-ko* and *hirame*.

137. Finished specimen of *togi-dashi*. Peacock's feather.

THE QUIN REPORT

128. Specimen of *togi-dashi* on *tagaya-san*. Branch of rose.
1. Outline of pattern. 2. Veining. 3. Powdering of gold-dust. 4. Coating of *rō-sé*. 5. Coating of transparent lacquer. 6. Ground down with magnolia charcoal. 7. Second coating of transparent lacquer. 8. Again ground with magnolian charcoal. 9. Thin coating of transparent lacquer applied with cotton wool. 10. Polished with *to-no-ko* and deer's-horn. 11. Thin coating of *yoshino* lacquer. 12. Polished with deer's-horn ashes. 13 and 14. Repetition of 11 and 12.

129. Specimen of *hiramakiye*. Flat lacquer on *shitan* (bamboo).
1. Outline of pattern. 2. Pattern filled in with *shitimaki* lacquer. 3. Powdered with gold. 4. Coating of *yoshino* lacquer. 5. Ground with camellia charcoal. 6. Polished with whetstone-powder and oil. 7. Veining drawn in *ke-uchi* lacquer. 8. Same, powdered with gold. 9. Thin coating of *yoshino* lacquer. 10. Polished with powdered-whetstone and oil. 11. Thin coating of *yoshino-nobe* lacquer and water. 12. Polished with whetstone-powder and oil.

130. Specimen of *takamakiye* (two views). Raised gold lacquer over clouded *togi-dashi*. 1. Corresponding with No. 6 of of *togi-dashi*. (Specimen nos. 126 & 127.) 2. Second coating of *rō*. 3. Ground down with magnolia charcoal. 4. Polished with *tonoko* and camellia charcoal. 5. Polished with deer's-horn ashes, after a coating of *yoshino* lacquer. 6. Camellia charcoal powder dusted over a coating of *shitamaki* lacquer. 7. Coating of *takamaki* lacquer over two applications of *yoshino-nobe* lacquer. 8. Same, ground with magnolia charcoal, and partly polished with camellia charcoal. 9. Polished with *tonoko* and oil. 10. Application of *keshi-fun* over *shitamaki* lacquer. 11. Application of *komaka-me-mijin* over *shitamaki* lacquer. 12. Coating of *yoshino* lacquer. 13. Polished with powdered-whetstone and oil. 14. Final polishings. Nos 12 & 13 repeated three times.

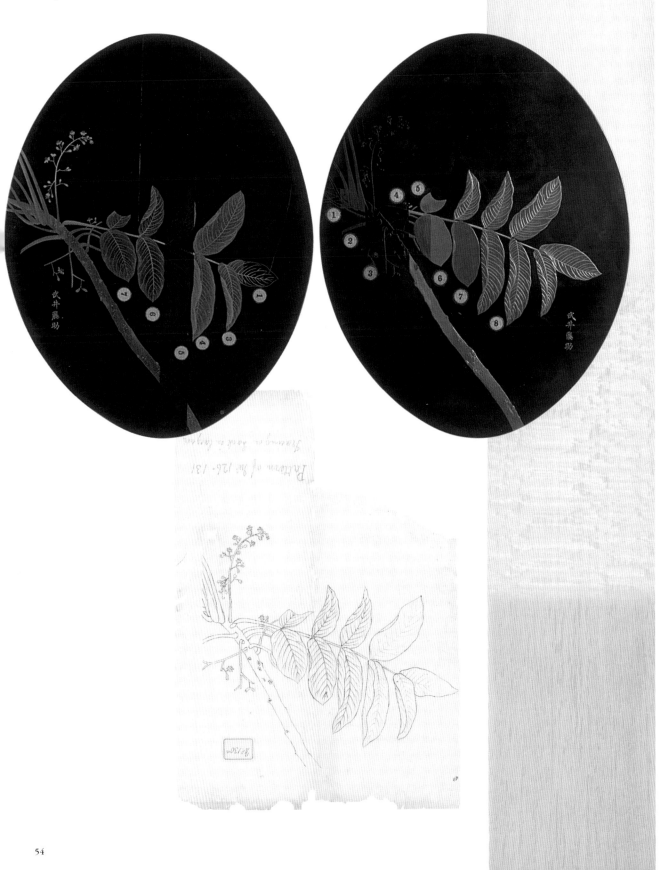

126. Specimen of *togi-dashi*. Branch of a lacquer tree. 1 and 2. Showing outline and veining. 3. Powdering of gold-dust. 4. Application of second coating of *rō-sé*. 5. Coating of *rō*. 6. Same, ground roughly with magnolia charcoal. 7. Second coating of *rō* to the finish.

131. Specimen of *takamakiye* on plain black ground. Branch of lacquer tree. 1. First tracing. 2. Coating of *shitamaki* lacquer and charcoal-powder; two coats of *yoshino-nobe* lacquer. Afterwards ground smooth with magnolia charcoal. 3. Coating of *takamaki* lacquer. 4. Ground with magnolia charcoal, and polished with *tonoko* and oil. 5. Gold-dust sprinkled over a coating of *shitamaki* lacquer. 6. A coating of *yoshino-nobe* lacquer. 7. Ground with camellia charcoal and polished with powdered-whetstone and oil. 8. Veining, and subsequent polishing three times.

130 A. Paper pattern used for producing above, with lacquer tracing on back.

12 JAPAN.

13. Next, the article is given a coating of *Kiriko*, likewise applied with the spatula, and the drying process is repeated for twenty-four hours.

14. This is a repetition of the same process, after which the article is set to dry for at least three days.

15. The surface is next ground smooth with a fine white whetstone.

16. A hardening coat of branch lacquer is given with a spatula, and set to dry for twenty-four hours.

17. A fresh coat of *Sabi* is applied with the spatula, and the article is put to dry in the press for twenty-four hours.

18. When thoroughly hardened the surface is ground smooth with a white whetstone, as before.

19. Next, a thin coating of branch lacquer is applied with the spatula, and the article is set to dry in the press for twelve hours.

20. A coating of *Naka-nuri* is then applied with a flat brush (*Haké*), and the article set to dry again for twenty-four hours.

21. On being taken out the surface is ground smooth with charcoal made from *Hōnoki* (*Magnolia hypoleuca*).

22. A thin coating of branch lacquer is given with cotton wool—old wool being chosen because less likely to leave hairs behind it—and rubbed off again with soft paper, after which the article is set to dry for twelve hours.

23. A coating of *Rō* (black lacquer) is then applied, and the article is set to dry for twenty-four hours.

24. The surface is rubbed smooth with a piece of charcoal made from *Hiyakujikko* (*Largerstramia indica*).

25 and 26 are repetitions of 23 and 24.

27. The surface is partly polished with finely-powdered *Largerstramia* charcoal, applied with a cotton cloth.

28. A coating of *Rō* is applied very thinly with cotton wool, and this is rubbed off again with soft paper, after which the article is inclosed in the drying press for twenty-four hours.

29. The surface is now polished with an equal mixture of powdered burnt clay from Mount Mari (*To-no-ko*) and calcined deer's-horn ashes, applied with a cotton cloth and a little oil (made from *Lesasnum orientalis*), till a fine polish is obtained.

30. A coating of branch lacquer is next given, applied with cotton wool very thinly, and the article is inclosed in the drying press for twelve hours.

31. The workman dips his finger in oil and rubs a small quantity of it over the surface, which he then polishes with deer's-horn ashes, applied with a cotton cloth, till a bright surface is obtained.

32. A coating of branch lacquer is applied as in No. 30, wiped off with soft paper, and set to dry for twelve hours.

33. The oil is applied as in No. 31, and then a final polishing with deers' horn ashes, given with the finger to the surface, which now assumes the most brilliant polish of which it is capable.

For articles that are liable to get rubbed, such as scabbards, these last two processes are repeated seven or eight times, the surface getting harder at each repetition, but this is not necessary for other articles even of the best quality. In describing the above processes the *minimum* time for drying has in each case been given, but for the first twenty-five processes the longer the article is kept in the press the better. From the twenty-eighth process to the finish it is better not to greatly exceed the times mentioned.

REPORT ON LACQUER INDUSTRY.

(*b.*) *Kata-ji* (hard basis). Class II.—Specimens sent.

The first six processes are the same as those used in making articles, Class I.

7. For wheaten lacquer substitute rice flour lacquer (*Shin*), the method of application being identical.

8. Same as in Class I.

9. Omitted.

10, 11, and 12. For No. 1 (*Jino-ko*), substitute No. 2 (*Jino-ko*).

13 to 18. Same as in Class I.

19. The article is now rubbed over with Indian ink mixed with water such as is used for writing purposes, and applied with cotton wool.

20 to 24. Same as in Class I.

25 and 26. Omitted.

27 to 33. Same as in Class I.

(*c.*) *Handan-ji* (half-step basis). Class III.

The first six processes are the same as those used in making articles, Class I.

7. Instead of hempen cloth, paper is frequently substituted.

8 and 9. Omitted.

10, 11, and 12. Three coats of No. 3 (*Jino-ko*) are given to the article, which is then dried in the sun instead of being inclosed in the press. The three coats can be applied in one day.

13 to 16. Omitted.

17. A coating of inferior *Sabi*, containing less lacquer, is applied, and dried in the sun only. As soon as the water has evaporated, a second coat (17*a*) is given and dried in the same manner.

18. Same as in Class I.

19. Same as in Class II.

20 to 33. Same as in Class II, likewise omitting 25 and 26.

(*d.*) *Manzo* (after a lacquer worker of that name). Class IV.

The first seven processes are identical with those in Class III.

8 and 9. Omitted.

10, 11, and 12. Three coats of No. 4 (*Jino-ko*), containing glue instead of lacquer—first introduced by *Manzo*—are given to the article. They are dried in the sun only.

13 and 14. Omitted.

15. The surface is ground even with a rough whetstone, and afterwards further smoothed with a spatula and a small quantity of water.

16. Same as in Class I.

17 and 17*a*. Same as in Class III.

18. Same as in Class I.

19 *et seq.* Same as in Class II.

The first four classes being modifications of each other, a comparative numbering was adopted but the following styles differ so materially that this plan can no longer be adhered to.

(*e.*) *Ka-no-ji* (inferior basis). Class V.

In this class the joints of the article to be lacquered are frequently not hollowed away, a strip of paper being merely pasted over them, and even this precaution being often omitted. A coating of *Ka-no-ji* (whiting and glue) is applied with a spatula twice or thrice, and dried in the sun.

4. The article is then wiped over with a wet brush and rubbed smooth with a white whetstone, and afterwards given an extra smoothing with the spatula.

132. Specimen of raised lacquer, with and without subsequent gilding. Branch of fir-tree and creeper. (The marking on the background is meant to imitate the surface of metal attacked by verdigris.) 1. Outline drawn and sprinkled with charcoal-dust. 2. Spikes of fir-tree, finished in *hira-makiye*. 3. Three applications of *shitamaki* lacquer and charcoal powder, afterwards polished. 4. Coating of *takimaki* lacquer, polished with camellia powder and *tonoko*. 5. Leaves powdered with gold, over a coating of *shitamaki* lacquer. 6. Coating of *yoshino-nobe* lacquer, afterwards ground with camellia charcoal, and polished with powdered-whetstone and oil. 7. Finished branch of tree made of several coats of *sabi* lacquer. 8. One finished leaf, showing application of *kiri-kane*; and one finished leaf showing method of shading with vermilion.

130 A. Paper tracing of 132.

The tree is a pine, *Pinus* sp., the creeper a species in the grape family (Vitaceae).

THE QUIN REPORT

14 JAPAN.

5. Sometimes a thin coating of *Nakanuri* or of branch lacquer is given to the article, but more frequently a coating of glue and lampblack, or of glue and soot mixed together, is applied.

6. A final coating of either *Jō-hana* or *Jōchiu* finishes the process without any subsequent polishing.

(*f.*) *Shibu-ji* (*Persimmon*)— (juice basis). Class VI.

The joints of the article are prepared in the same manner as for Class V, but, instead of *Ka-no-ji*, four or five coats of *Shibu-ji* (Persimmon juice and lampblack) are applied with a brush; these dry very rapidly and the final coating is smoothed with *Tokusa* (*Equisetum*).

5. A final coating of either *Jō-hana* or *Jō-chiu* is given as in Class V.

This kind of article is chiefly made in Aidzu, and, indeed, goes by the name of "Aidzu Ware." It has not such a good appearance as *Ka-no-ji*, for the grain of the wood is easily traceable under the lacquer, but being made without glue, it stands water much better, and is in general request for rice bowls and *zen* (small dinner trays with legs, one of which is set before each guest).

(*g.*) *Sabi-Sabi* (double Sabi). Class VII.

In this class of goods the joints are generally hollowed out, and a basis-hardening coat of branch lacquer given. Paper is also pasted over the work after filling in the joints with *Koku-so*. Three coats of inferior *Sabi* are then applied, and after drying for about twelve hours in the press, the article is ground smooth with a white whetstone. Next comes a coating of branch lacquer, applied with cotton wool, and then one of *Nakanuri*, which is ground smooth with *Magnolia* charcoal. Another coating of branch lacquer is followed by one of *Jō-hana* or *Jō-chiu*, and the article is finished without further polishing. Drying in the damp press is requisite between each process for this class of lacquer.

It is manufactured only in Tôkiô, though the processes for the under coats of *Wakasa* lacquer are identical. The method adopted for completing *Wakasa* lacquer is described, p. 13 of the accompanying pamphlet. Rice bowls, drinking cups, and luncheon boxes, &c., are the usual articles manufactured. In this, as in Aidzu ware, the grain of the wood is traceable, and its common appearance constitutes the reason for classing it so low, but in actual excellence and durability it ought to rank fourth next to *Handan-ji*.

(*h*) *Kaki-awase* (mixture), or *Kuro-shunkei* (black Shunkei), from the name of its inventors. Class VIII.

In this class of goods the wood is given a basis-hardening coat of branch lacquer mixed with lampblack, over which is laid a final single application of *Jō-hana* or *Jō-chiu*. This ware is made at Tôkiô, and is used for cheap rice bowls and boxes. For the commonest kind of work a mixture of glue and lampblack or persimmon juice and lampblack is used, instead of branch lacquer as a ground coat.

(*i.*) *Aka-shunkei* (red Shunkei). Class IX.

This kind also derives its name from the inventor. For making articles of this class, which show the natural grain of the wood, a mixture of *Yoshino* lacquer and gamboge is rubbed on with a hard brush, after which they are inclosed for a day in the press to dry, and then a coating of *Shu-urushi* (transparent lacquer, containing a proportion of *Perilla ocymoides* oil) is applied. When dry it presents a polished surface, and it appears dark when at first finished, but in a few months becomes much lighter. A cheaper quality of *Shunkei* is made by using glue and gam-

134. Finished specimens of *giyōbu-nashiji*, of mixed gold and shell work, and of pattern for a border.

135. Specimen of lacquering on metal.

It features a species of *Anemone*.

REPORT ON LACQUER INDUSTRY.

boge or Persimmon juice and oxide of iron for the under coat, but though the colour has a better appearance at first, it gradually deteriorates.

The best is made in the Province of Dewa, at Akita. For the most part soft woods are used in making this ware.

(j.) *Ki-ji-ro* (colour of the grain of wood).

1. Well-seasoned wood is selected, and the article having been carefully smoothed—
2. A thin coating of *Yoshino* lacquer is applied with a brush, after which it is set to dry in the press for twelve hours.
3. A coating of best *Sabi* is then applied with the spatula, and set to dry in the press as usual.
4. This is ground completely away with a green whetstone.
5. A coating of *Nashiji* (pure transparent lacquer) is now given, and the article is inclosed in the press for twenty-four hours.
6. It is again ground with a green whetstone till no remains of the lacquer coating are apparent.
7. Then follows a second coat of transparent lacquer, which, after drying as before,
8. Is ground smooth with a piece of *Hiyakujikko* (*Largerstramia indica*) charcoal.
9. Transparent lacquer is again applied with a piece of cotton wool, and wiped off with soft paper, and the article is set to dry for twelve hours.
10. Afterwards it is given a preliminary polish with an equal mixture of *To-no-ko* and deers' horn ashes applied with a cotton cloth and a little oil.
11. Next, a coating of *Yoshino* lacquer is applied with cotton wool, wiped off with paper, and set to dry as before.
12. At this stage only deers' horn ashes, with a trifle of oil, are used for polishing. This process is repeated three times, and results in an exceedingly brilliant polish. Only hard woods are used for this kind of ware.

(k.) *Red and Coloured Lacquers.*

For making best red and other coloured lacquers the first twenty-two processes are the same as in *Honji*, Class I. Next a mixture of *Nashiji* (pure transparent lacquer) and vermilion, or the colour desired, is given to the article, which is thereupon set to dry. The remainder of the processes are identical with Class I, except that in Nos. 30 and 32 *Yoshino* lacquer is substituted for "branch lacquer," and in No. 28 transparent varnish is used instead of *Rō* (black lacquer). For extra high-class work, instead of the thin coating of lacquer (No. 28) which is wiped off again, a thick coating of transparent varnish is given, applied with a brush, and set to dry for about thirty-five hours, the remaining processes remaining unchanged.

For second-rate articles the colour is mixed with *Shu-urushi* (transparent lacquer containing oil), No. 23, and no after polishing takes place. The article presents a brilliant surface, and the colour is better and brighter than in the best kind, but the surface much less hard. Many processes are omitted for cheaper articles, as is the case in black lacquer, and less lacquer and more oil is used.

Colouring Matters used.

Shu (vermilion).—For red lacquer, used also mixed with gold dust for shading.

Sei-shitsu (green lacquer).—A mixture of *Kiō* (chrome yellow) and *Bero-ai* (Prussian blue).

136. Tray showing process of applying *nashiji*. 1. Pure gold *nashiji*. 2. Koban gold *nashiji*. 3. Silver *nashiji*. Back of tray silver *nashiji*. 4. Tin *nashiji*. 5. Coating of transparent lacquer. 6. Ground roughly with magnolia charcoal. 7. Second coating of transparent lacquer. 8. Ground smooth with magnolia charcoal. 9. Transparent lacquer applied with cotton-wool. 10. Polished with powdered charcoal and *tonoko*. 11. Thin coating of *yoshino* lacquer. 12. Polished with deer's-horn ashes and oil. 13. Second thin coating of *yoshino* lacquer. 14. Polished deer's-horn ashes and oil.

THE QUIN REPORT

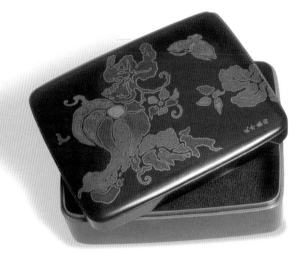

138. Box showing various modes of applying *kiri-kane*, *awo-gai*, *hirame*, and shading colours to produce patterns (unfinished).

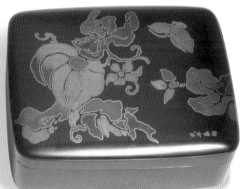

139. Similar kind of box (finished).

136 A. Specimen of common tin *nashiji*.

Muras-aki-ko (purple powder).—A mixture of white lead and *Tō-beni* (*Magenta roseine*).

Benigara (red oxide of iron).—Sometimes used instead of vermilion.

In the district of Aidzu the light colours are produced to the greatest perfection, viz., yellow, green, and intermediate shades. In Tôkiô, though the same materials are used, the resulting colours are inferior and darker. In Aidzu no after polishing takes place with coloured lacquers. The lacquer is applied like paint. Tôkiô is, however, best for black lacquer, as well as for such high-class red, &c., as are polished afterwards. These differences are attributed to some climatic influence. The *Kioto*, so called "black lacquer," shows a reddish-brown tinge. With the exception of Tôkiô, Kioto, Osaka, Kaga, Tsugaru, Wakasa, Nagoya, Suruga, and Shidzuoka, and one or two isolated places, the method of smoothing with charcoal and afterwards polishing is not pursued. In Tsugaru and Wakasa neither flat nor raised gold lacquer are manufactured.

It should be mentioned that the plain lacquered articles are almost exclusively manufactured by one set of workmen, who supply the workers in gold lacquer with the articles ready for the application of the gold powdering, various patterns, &c.

The wholesale lacquer trade is in the hands of a few large merchants. In Tôkiô there are two houses only. These receive the crude lacquer from the producers as it arrives from the various districts, either buying it outright or making advances to the contractors, who are bound by the rules of the guild to deliver only to them. They sell it in quantities as required to the lacquer manufacturers, who prepare and refine the sap for the market, and these again retail the material to the lacquer workers. The various processes that the lacquer undergoes in the hands of these manufacturers before retailing are kept secret, only the approximate mixtures being known.

That all lacquer, even that sold as pure lacquer, undergoes some adulteration, is rendered evident from the fact that, in accordance with a strange custom peculiar to the lacquer trade, the retail manufacturers sell even the smallest quantity at the same rate at which they buy it from the wholesale merchant.

Tools and Materials used in the manufacture of Gold Lacquer.

Neji-fude.—Brushes made of rats' hair, used for tracing out the patterns, and for drawing the very fine lines, &c. The best are made of the long hairs from the backs of "ship rats," whose fur is not so likely to get rubbed.

U-no-ke-usuji-fude (fine brushes made of hares' hair).—These are a little larger than rats' hair brushes, and are used for filling in the patterns of the best articles, also for drawing outlines on common articles and ground work. There are two sizes, *Dai* and *Sho*, used for drawing "large" and "small." There are besides five sizes of *Ji nuri fude* (grounding brushes), known as—

T-cho (number one).
T-cho-han (number one and a-half).
Ni-cho (number two).
Ni-cho-han (number two and a half).
San-cho (number three).

U-no-ke-hake (a flat brush made of hares' hair, used for spreading the lacquer on large pieces of work).—There are two sizes used.

Men-sō (a stiff brush made of deer's hair, used for applying the *Sabi*, &c., in making raised gold lacquer).—It is only used for stiff mixtures.

Haké (flat brushes of human hair, for smoothing the lacquer after application, as in ordinary plain lacquer).—There are two sizes used.

LACQUER LEGACY

140. Specimen of inlaying work: in coral, various shells, deer's-horn, &c. 1. *Hirame* applied over *rō-sé*. 2. Shell-work, &c., having been applied, three coats of *sabi* have been given, and then ground smooth. 3. Coating of *rō* lacquer. 4. Same, ground down with magnolia charcoal. 5. Second coating of *rō* lacquer, same ground away with magnolia charcoal and polished with *tonoko* and oil. 6. A coating of branch lacquer, afterwards polished off with deer's-horn ashes and oil. 7. *Hirame*. Polished after laquering. 8. The whole of the inlaid work polished and the veining of the leaves completed; bottom of tray in silver *nashiji*.

The plant, with conspicuous tendrils, is a species in the bindweed family (Convolvulaceae).

141. Stand for wine cup in *togi-dashi*. Kioto work. About fifty years old.

Bun-mawashi (compass with fine brush attached for describing circles).

Ké-bo (brushes made from the long body hairs of a horse, used for smoothing the fine gold powder and brushing off extra particles, used also for dusting).—There are four sizes.

Fude-kake (brush rest).

Fude-arai (brush cleaner, made either of ivory or tortoise-shell).—The brushes have to be very carefully cleaned after using with *Sesamum orientalis* oil, to remove every trace of lacquer.

Tsutsu (a quill, from the wing of a swan or crane, over one end of which is stretched a piece of silk, used for scattering the gold dust).—There are two sizes used.

For applying *Nashiji* or *Hirame* bamboo tubes of three different sizes are used, with silk of more open texture.

Saji (spoon), for putting the gold dust into the quill or bamboo tube.

Hirame-fude.—A pointed piece of bamboo or other wood, used for picking up and applying *Hirame*, or the gold, or shell squares.

Kujira-bera (whalebone spatula).—Used for mixing the materials, and also when transferring the tracing on the paper to the article to be painted (process described farther on). The kind used is called island whalebone, and comes from China; that obtained from Japan is practically useless, being liable to split. Two sizes are used.

Hera.—Spatulas made of *Hinoki* (*Chamæcyparis obtusa*), smaller than those used by workers in plain lacquer. There are three sizes used for applying plain lacquer, and three sizes for applying *Sabi*.

The *Tooth* of a fish, ordinarily the *Tai* (*Cerranus marginalis*), fastened with lacquer on to a piece of bamboo, used for polishing such crevices as are too small to admit of charcoal, &c., being used.

A piece of polished shell, used for smoothing the paper on which the pattern is drawn before tracing with lacquer.

Tsume-ban.—A palette, made either of tortoise-shell or buffalo horn, worn on the left thumb.

Take-ban.—A small bamboo board, used when cutting the gold and silver foil into squares.

Jō-ban.—Box for holding brushes, &c. (described before).

Tsuno-ko-ban.— (Described above.)

Fun-bako.—A flat black-lacquered box for holding the gold dust.

Charcoal of three kinds.

Hono-ki (*Magnolia hypoleuca*).

Tsubaki (*Camellia japonica*).

Hiyakujikkō (*Largerstramia indica*).

Shiō (gamboge).

To-no-ko, Jino-ko, Tsuno-ko, To-ishi.—(Described above.)

Gold and Silver Dust used for Ornamentation.

Of these there are several kinds, viz.: *Yasuri-ko* or *fun* (file-powder), made in *Yaki-kin*; (Pure gold) *Koban-kin* (10 parts gold to $2\tfrac{6}{10}$ silver); *Gin* (silver).

There are twelve qualities of each differing in fineness, and are known by the following names, beginning with the coarsest:—

(N.B.—For sake of reference, the numbers are made to correspond with those on the specimen board.)

1. *Ara-tsune.*
2. *Chiu-tsune.*
3. *Komaka-me-tane.*

4. *Mijin-tsune.*
5. *Hanako.*
6. *Mijin.*
7. *Komaka-me-mijin.*
8. *Aragoku.*
9. *Goku-gashira.*
10. *Goku-mijin.*
11. *Komaka-me-goku-mijin.*
12. *Usuji.*

Besides these, there is an extra large kind, used for ground-work, called *Hira-me* (flat-eye). The coarsest filings, whether of pure gold, *Koban*, or silver, are taken and rolled out flat on an iron plate. Of *Hirame* there are eight kinds each, known by the following names:—

13. *Dai-dai-ichi.*
14. *Dai-ichi.*
15. *Dai-ni.*
16. *Dai-san.*
17. *Ai-no-san.*
18. *Tsune-no-san.*
19. *Shō-san.*
20. *Saki.*

Next comes the kind called *Nashiji*, from its resemblance, when applied to the article, to the rind of a pear.

Nashiji is used for ground-work, in making which pure gold, also *Koban-kin* (10 parts gold, $2\frac{6}{10}$ silver), *Jiki-ban* (10 parts gold, $3\frac{2}{10}$ silver), *Nam-ban* (10 parts gold, $3\frac{6}{10}$ silver), and silver, of seven qualities of fineness each, are used.

21. *Dai-ichi.*
22. *Dai-ni.*
23. *Dai-san.*
24. *Ai-no-san.*
25. *Tsune-no-san.*
26. *Shō-san.*
27. *Saki.*

Aka-fun (red powder), Nos. 28, 29, and 30, is vermilion mixed with pure gold, *Koban-kin*, and silver, for shading.

Kuro-fun (black powder), Nos. 31, 32, and 33, is camellia charcoal powder mixed with pure gold, *Koban*, and silver.

Giyōbu nashiji is the coarsest kind of *Nashiji* made; 34, pure gold, and 35, silver; but it is little used, as it requires seven or eight coats of lacquer to be applied before it is covered sufficiently to stand polishing.

Awogai-mijin (fine green shell), No. 36, is a specimen of the application of powdered shell as ground-work.

Keshi-fun.—This is the finest kind used; it is only made in pure gold and *Koban*, Nos. 37 and 38. This is made by mixing gold-leaf in liquid glue till it is reduced to an impalpable powder; water is then added, and when the gold sinks the liquor is poured away. This is repeated till all the glue has been got rid of.

Shaku-dō fun.— A mixture of seven parts pure gold and three parts of copper powder, No. 39.

Kana-gai.—Foil made of pure gold, *Koban*, and silver, Nos. 40, 41, and 42. It is made of four thicknesses in each quality, viz.: *Hon-neji*, *Chiu-neji*, *Usushu*, *Kime-tsuke*, the last being the thinnest.

Besides the above, there are several mixtures, as—

THE QUIN REPORT

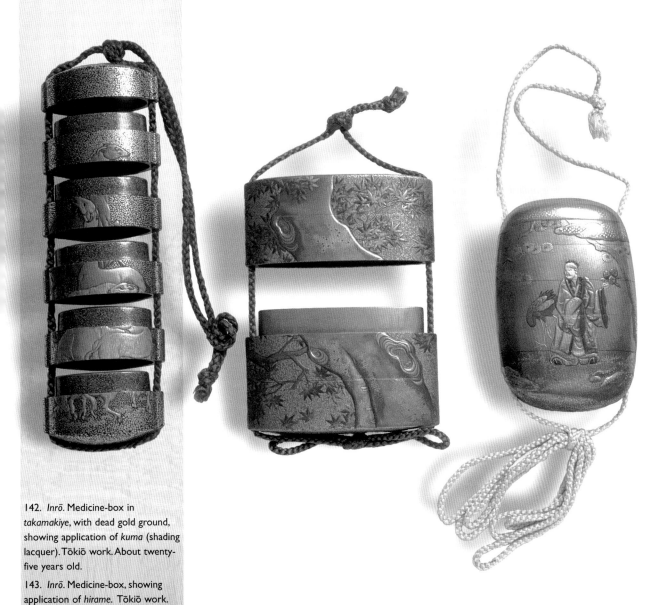

142. *Inrō*. Medicine-box in *takamakiye*, with dead gold ground, showing application of *kuma* (shading lacquer). Tōkiō work. About twenty-five years old.

143. *Inrō*. Medicine-box, showing application of *hirame*. Tōkiō work. Estimated at over one hundred years old.

144. *Inrō*. Medicine-box, showing method of shading, &c. Tōkiō work. About eighty to one hundred years old.

146. Tray. Negoro ware. Over fifty years old.

145. Tray. Inlaid shell-work. Kioto work. Estimated age, one hundred and twenty years.

REPORT ON LACQUER INDUSTRY.

Kuri-iro-fun (chestnut-coloured powder).—A mixture of one-half gold dust with powdered camellia charcoal and vermilion.

Nedzumi-iro-fun (rat-colour grey).—A mixture of half silver and powdered camellia charcoal, and a little vermilion.

In each case it is evident that several distinct shades can be obtained according as more or less colour is added to the gold and silver dust. It is a remarkable fact that (as I am informed) no vegetable colours can be used with lacquer. They are all eaten up, as it were, by the lacquer and disappear, which accounts for the very few variations seen in the colours of lacquer. The workmen have never been able to produce white, purple, or any of the more delicate shades.

Of late years, since cheap work has been introduced, the custom of using tin dust has been adopted for making common *Nashiji*. It is manufactured of the same sizes as in gold and silver and when plenty of gamboge is mixed with the lacquer to cover it an inexperienced person might easily mistake it for gold when the ware is new, but it soon deteriorates. Burnt tin dust is also sometimes used for under coats in making cheap raised lacquer.

Mode of making Gold Lacquer.

(a.) *Togi-dashi* (bringing out by polishing).—The article having been subjected to the first twenty-two processes, as described in making *Houji* (Class I) is then treated as follows:—

The picture to be transferred to the article is drawn on thin paper, to which a coating of size made of glue and alum has been applied—that known as *Mino-gami* is best. The reverse is rubbed smooth with a polished shell or pebble, and the outline very lightly traced in lacquer, previously roasted over live charcoal to prevent its drying, with a fine brush made of rats' hair. The paper is then laid, with the lacquer side downwards on the article to be decorated, and is gently rubbed with a whalebone spatula wherever there is any tracing, and on removing the paper the impress may very faintly be perceived. To bring it out plainly, it is rubbed over very lightly with a piece of cotton wool, charged with powdered white whetstone or tin, which adheres to the lacquer. Japanese paper being peculiarly tough, upwards of twenty impressions can be taken off from one tracing, and when that is no longer possible, from the lacquer having become used up, it only requires a fresh tracing over the same paper to reproduce the design *ad infinitum*. This tracing does not dry owing to the lacquer used for the purpose having been partially roasted, as previously mentioned, and can be wiped off at any time.

The next process is to trace out the veining of the leaves, or such lines to which in the finished picture it is desired to give the most prominence, and these lines are powdered over with gold dust through a quill. The qualities called *Mijin*, *Koma-kame-mijin*, and *Aragoku*, are generally used; either finer or coarser qualities cannot be used. The article is then set to dry for twenty-four hours in the damp press. The outline is now drawn carefully with a rat's hair brush over the original tracing line with a mixture of black and branch lacquer, called *Rō-sé*. The whole is then filled in with *Rō-sé* applied with a hare's hair grounding brush. Gold dust of a slightly coarser quality than *Mijin* is scattered over the lacquered portion, and the article is set to dry for twenty-four hours. Another thin coating of *Rō-sé* lacquer is again given to the gold-powdered portions, and the article set to dry for twelve hours. Next, a coat of *Rō* (black lacquer) is applied over the whole surface of the article, which is set to dry for at least three days. It is then roughly ground down with *Magnolia* charcoal, the surface dust being constantly wiped off with a damp cloth till the pattern begins to appear faintly. Another coating of *Rō* lacquer is

JAPAN.

then given and the article set to dry for thirty-six hours. It is again ground down with *Magnolia* charcoal as before, this time till the pattern comes well out. The ensuing processes are the same from 28 to 33 inclusive, as in black lacquer (*Honji*, Class I).

In making *Togi-dashi* on hard woods, transparent lacquer is used instead of *Rō*.

(b.) *Hira-makiye* (flat Gold Lacquer).

The article having been thoroughly finished, either in black or red, &c., as already described under the head of *Honji*, Class I, and the following kinds, a tracing is applied to the surface as in *Togi-dashi*, the outline is carefully painted over with a fine brush of rat's hair, and then filled in with a hare's hair brush, using *Shitamaki* lacquer (branch lacquer and red oxide of iron). Over this surface gold dust, of the quality called *Aragoku* being generally used, is scattered with a brush of horse's hair (*Kebo*) till the lacquer will not absorb any more. The article is then set to dry for twenty-four hours. A thin coating is next applied over the gold, of transparent lacquer or *Yoshino* lacquer, and set to dry for twenty-four hours at least. It is then most carefully polished with camellia charcoal, and finally polished off with *Tono-ko* and a little oil on the point of the finger, till the ornamented portion attains a fine polish. The veining of leaves and the painting of stamens, &c., of flowers, or such other fine work, is now done with a fine rat's hair brush charged with *Ke-uchi* lacquer over which fine gold dust (*Goku-mijin*) is scattered from a brush of horse's hair (*Kebo*) as before, and the article set to dry for twelve hours. Some *Yoshino* lacquer is then applied to a piece of cotton wool, and rubbed over the whole surface of the box or other article, and wiped off again with soft paper. It is set to dry for twelve hours, after which it is polished off with deer's horn ashes and a trifle of oil. When very high-class work is desired, *Yoshino* lacquer, to which a little water has been added, is applied, and polished off a second time, and a very brilliant surface is attained.

More ordinary "flat gold lacquer" differs in the manufacture as follows : The tracing is accomplished in the same manner, but *Shitamaki-nobe* lacquer (branch lacquer, red oxide of iron, and camphor) is used for filling in the pattern with a hare's hair brush. The article is then set to dry in the press for ten to twenty minutes, during which time the lacquer has begun to harden, and less gold will adhere. Then gold dust (*Goku mijin*) is applied with cotton wool thinly, and the article is set to dry for twenty-four hours. The whole surface is then smeared over with *Yoshino-nobe* lacquer (*Yoshino* lacquer and camphor) on a piece of cotton wool, and wiped off again with soft paper. The reason is that it is less trouble to smear over the whole surface thinly, and it is, moreover, not necessary to give a thick coat of lacquer to the decorated part, as the gold dust has been very thinly applied. It is set to dry for twelve hours and ground smooth with camellia charcoal and polished with powdered whetstone and oil on the point of the finger. The fine lines are then drawn with a rat's hair brush charged with *Shitamaki* lacquer, and sprinkled with gold dust (*Goku-mijin*) from a brush (*Kebo*), and the article set to dry for twelve hours. The whole is again smeared with *Yoshino-nobe* lacquer and carefully wiped off again with paper, and set to dry for twelve hours. The article is then polished with powdered whetstone and oil on the point of the finger, and a second application of *Yoshino-nobe* lacquer with a little water, wiped off with soft paper, set to dry for twelve hours, and finally polished off with deers' horn ashes and oil on the finger, finishes the operation.

Should it be required to make any dark spots or lines, such as birds'

147. Medicine-box of *tsuishu*. Estimated over fifty years old.

148. Box of *tsui-koku*. Carved black lacquer. Estimated age, over one hundred years.

149. Box of the style called "Guri". Estimated age, over fifty years.

THE QUIN REPORT

eyes, or to draw human hair, &c., or other shading, this is done last of all with *Kuma*, "bear" lacquer, *Jō-hana*, and lampblack.

More Common Kind of Flat Gold Lacquer Painting.

Instead of tracing the design in roasted lacquer, it is done with a mixture of powdered *Tono-ko* and water, and the impression is transferred to the articles with the whalebone spatula as before. The reason for only using *Tono-ko* instead of lacquer is that the ground-work being inferior it cannot be ground or smoothed afterwards, and the edges of the pattern would not be clean, nor stand out clear, should any lacquer get smeared outside the tracing line. The outline is then filled in with *Shitamaki-nobe* lacquer with a coarse hare's hair brush, and the article is set to dry for twenty minutes, or till a thin skin has formed on the lacquer, and then the half-dry surface is wiped over with cotton wool charged with *Keshi-fun*, the finest gold powder, and set to dry for five or six hours. The whole surface is then smeared with *Yoshino-nobe* lacquer, which is carefully wiped off again with soft paper, and the article set to dry for half-a-day. The surface is then rubbed over gently with deers' horn ashes and soft paper to give it a polish, and to get rid of any of the last coat of *Yoshino-nobe* lacquer.

The fine lines are now drawn with a fine hare's hair brush charged with *Shitamaki-nobe* lacquer, and the article set to dry for twenty minutes or so; then *Keshi-fun* is applied with cotton wool, and again set to dry for five or six hours. No further process takes place.

(c.) Taka-makiye (raised Gold Lacquer).

The ground-work may be either black or coloured lacquer, *Nashiji* (pear basis of gold dust), or the plain wood. The outlines of the pattern are transferred to the surface of the article in the same manner as in *Togi-dashi*, or "flat lacquer." The outline is then painted over with *Shitamaki* lacquer, and this is covered with powdered camellia charcoal. If the outside is to be higher than the inside, a broad margin is painted and covered with the charcoal powder, leaving the centre untouched, and *vice versâ*; if the centre is to be higher a faint line only is painted outside, and the inside is given a thickish coating, which is sprinkled with the charcoal dust, and the article set to dry for twelve hours. When taken out of the press it is well dusted to get rid of any loose charcoal powder, and is also washed, using a brush made of human hair (*Hake*) to clean out all crevices and bring out the lines, &c. Some *Yoshino-nobe*, or "branch lacquer," with camphor, is now rubbed on with a piece of cotton wool and carefully wiped off with soft paper, and the article set to dry for twelve hours. The raised parts are next carefully ground smooth with a piece of *Magnolia* charcoal, and a second coat of *Yoshino-nobe*, or of "branch lacquer," is applied as before and dried.

[If a well-raised pattern is required, one, two, or even three coats of *Sabi* ("branch lacquer" and *Tono-ko*) are applied, the outside edges being painted with a brush of deer's hair (*Menso*), and the inside lacquer applied with a small *Sabi* spatula, the article being set to dry between each application for twelve hours. For coarser work it is then ground smooth with a white whetstone, and for finer work with a yellow whetstone. Over this some "branch lacquer," mixed with camphor, is rubbed with cotton wool and wiped off with soft paper, and the article set to dry for twelve hours.]

If the pattern is not to be very high the operations described between the brackets are omitted. A coating of *Takamaki* lacquer is now given, the outside edges being carefully drawn with a rat's hair brush, and the inside of the pattern filled in with a hare's hair brush, and the article set

THE QUIN REPORT

153. Round tray. *Loo-choo* red lacquer.

151. Wine-cup. Kioto work. Red and yellow lacquer. Gilt inside. Estimated age, over fifty years.

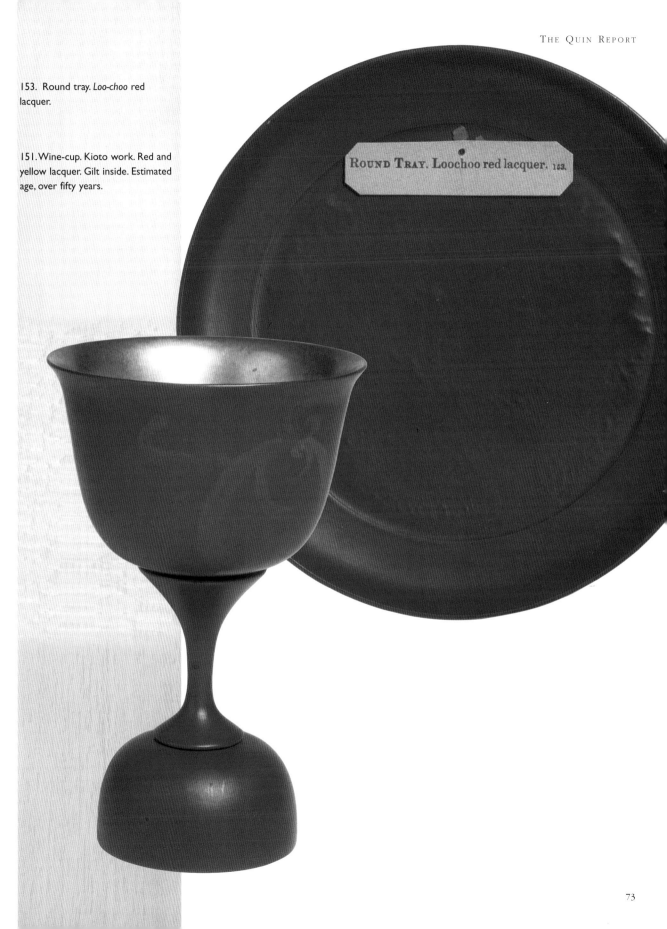

155. Specimen boards, showing design on red lacquer, in gold, and *rō-sé*, through transparent lacquer. Tōkiō work.

The larger plant is a species of *Hibiscus*, the smaller a grass (panicoid).

154. Paper tray lacquered over. Tōkiō work.

to dry for thirty-six to forty-eight hours. When taken out of the press the surface is ground smooth with *Magnolia* charcoal, and then partly polished with powdered camellia charcoal on a cotton cloth. A little oil is now rubbed on, and a further polishing takes place with powdered "whetstone" on a cloth. Next "branch lacquer" is rubbed over the raised parts with cotton wool and wiped off with soft paper, and the article set to dry for twelve hours. It is next polished with deers' horn ashes and a little "rape seed," or "sesamum" oil applied on the point of the finger. Up to this point the formation of the pattern, whether mountains, waves, trees, men birds or animals, has been gradually completed.

If small squares of gold foil (known as *Kiri kane*), or of coloured shell, are used in producing the pattern, they are now applied one by one on the point of a bamboo stick (*Hirame fude*) the spot where they are to be affixed having been smeared with a little *Rō-sé* lacquer to make them adhere. When all that is required has been affixed, a piece of soft bibulous paper is spread over the freshly done parts and pressed very carefully with the finger. This is to get rid of as much of the *Rō-sé* lacquer as is not covered by the gold squares as possible; the article is set to dry for twelve hours, and then the portion where the gold has been applied is gently polished with a little camellia charcoal on the point of the finger, to get rid of the remainder of the *Rō-sé* lacquer. Shell patterns, and the coarser kinds of gold dust that may be required, are applied in the same manner. The finer kinds of gold dust are applied next, over a coat of *Shitamaki* lacquer, and the article set to dry for twelve hours. The remaining processes of polishing, drying, &c., are the same as in first-class "flat gold" lacquer.

For making raised lacquer patterns on plain wood the whole surface is covered with tin-foil, stuck on with rice paste, to keep the wood quite clean, and then the place only where the pattern is to come is cut out. In making all high-class lacquer the edges of every article are pasted over with tin-foil to prevent their being rubbed or injured by the workman, and the same is done over each portion as it is finished.

The above is the ordinary method of making best raised lacquer, but from a glance at the specimens which accompany this paper it will be seen immediately that there are such innumerable modifications of one process or another, according to the object to be produced, that it is manifestly impossible to do more than give the above cursory sketch. Nearly every piece of good lacquer made exhibits a specimen of each kind, viz. *Nashiji*, *Togi-dashi*, *Hira-makiye*, or *Taka-makiye*.

In making raised lacquer on inferior articles the methods do not vary much from the good kinds; the work is merely less carefully executed. The saving is in the quantity and quality of the gold dust used, and the absence of minute after work, or in the use of silver and tin instead of gold dust. In the very cheapest kinds burnt tin dust is used instead of charcoal over the first coat of *Shitamaki*. This is burnished bright, and over it a thin coating of lacquer and gold dust is applied. At first it looks well, but loses its colour in a year or two. By using tin powder the same height is attained in one coat that would necessitate at least three coats of lacquer and charcoal dust. This kind of work is, however, only used for cheap articles for foreign export, and has been quite lately introduced.

(d.) *Lacquering on Metal.*

For lacquering on iron or copper, brass or silver, the metal is smoothed and polished, and then given a coating of "crude lacquer," or "black lacquer;" the article is put over a charcoal fire, and the lacquer is burnt on to the metal till all smoke ceases to escape. The fire must not be too fierce, and the metal must not be allowed to get red hot, or the lacquer

turns to ashes. After the lacquer has burnt quite hard the surface is rubbed smooth with *Largerstramia* charcoal; these operations are repeated three or four times, till a good foundation of lacquer has been obtained. Then the same operations exactly are repeated as in making best "black lacquer," *Togi-dashi*, "flat gold lacquer," or "raised gold lacquer," only that the lacquer is burnt dry over the fire instead of being dried in the press. The lacquer is thus rendered quite hard and very durable. After the first two or three coats have been burnt on, the subsequent drying processes can be carried on in the damp press, should it be so desired.

In winter, or when any article is required in a hurry, the workmen sometimes put a charcoal fire in the press, over which a pan of hot water is placed. The steam which is thus generated helps to dry the lacquer in an hour or two, which would take twenty-four hours to harden ordinarily, but the lacquer thus dealt with loses its strength, and is never very hard. "Black lacquer" turns a rusty brown, the colouring virtue of the iron being apparently lost, and therefore this plan is never adopted for good work, and in second-rate work only for under coats.

Nashiji (pear basis).—This style of ornamentation, occupying an intermediate position between plain and ornamental lacquer, is therefore treated of last. Till the opening of Japan to foreign trade it was in the hands of workers in gold lacquer, but now for the most part all *Nashiji* on articles intended for exportation is applied by the workers in plain lacquer. In making best *Nashiji*, as in *Togi-dashi*, the first twenty-two processes are identical with *Honji*, Class I. A coating of *Rō-sé* is applied, and the gold dust is sprinkled over this surface through one or other of the bamboo tubes, according to the fineness required. The article is set to dry in the press for forty-eight hours, and is then given a coating of pure transparent varnish. This is set to dry for three or four days, when it is roughly ground with *Magnolia* charcoal, and a second coat of transparent lacquer given. The article is set to dry for forty-eight hours, and then ground with *Magnolia* charcoal till a perfectly smooth surface is obtained. Transparent lacquer is then applied with a piece of cotton wool, and wiped off again with soft paper, and the article set to dry for twenty-four hours. It is then polished with a mixture of *Tono-ko* and camellia charcoal powder and a little oil. Next, a coating of *Yoshino* lacquer is given, and wiped off with paper; the article is set to dry for twelve hours, and then it is polished with deer's-horn ashes and oil. This is repeated three times to finish the article.

The same processes are gone through when using silver instead of gold dust.

For cheap qualities tin dust is used, and the powder is scattered on glue immediately above a coating of *Kanoji* (whiting and glue). When the article is dry it is burnished with *To-kusa* (*Equisetum*), and as soon as it presents a bright surface a coating of pure transparent lacquer, with gamboge, is given to it. It is set to dry for a day in the press, and then ground with *Mognolia* charcoal. Over this a coating of *Shu-urushi* (transparent varnish containing oil) is applied, and another drying for twenty-four hours completes the process.

(Signed) JOHN J. QUIN

Tokio, January 13, 1882.

THE QUIN REPORT

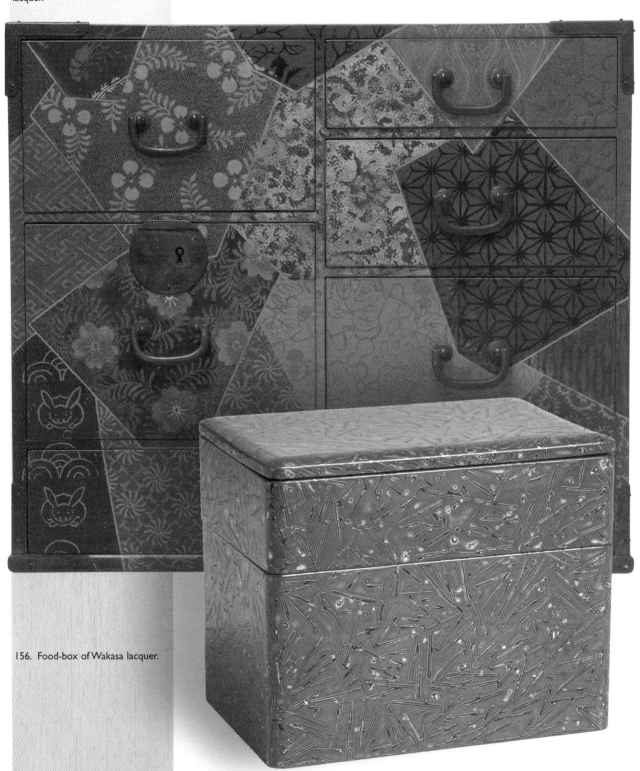

157. Cabinet of *tsugaru-nishiki* lacquer.

156. Food-box of Wakasa lacquer.

Lacquer Legacy

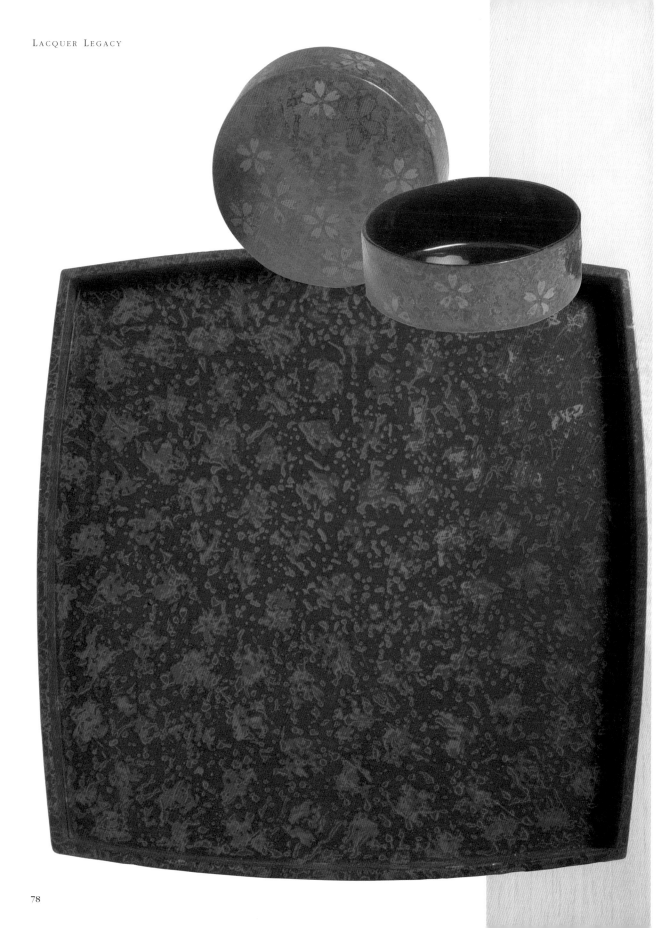

JAPAN.

CATALOGUE OF SPECIMENS FORWARDED.

[The specimens alluded to in the Report are exhibited in No. 1 Museum, in the Royal Gardens at Kew.]

1. Kawa-muki. Bark-parer.
2. Yeda-gama. Branch sickle.
3. Kaki-gama. Scraping sickle.
4. Yeguri. Gouge.
5. Natsu-bera. Summer spatula.
6. Hōchō. Knife.
7. Seshime-bera. Seshime spatula.
8. Gō. Bamboo or wooden pot to hold the lacquer.
9. Gō-guri. Pot gouge.
10. Te-bukuro. Glove.
11. Specimens of lacquer tree (small).
12. ,, ,, (larger size).
12 A. Small stems.
13. Hinoki. (*Chamæcyparis obtusa.*)
14. Kiri. (*Paulownia Imperialis.*)
14 A. Kiri (old).
15. Hōnoki. (*Magnolia hypoleuca.*)
16. Sawara. (*Chamæcyparis pisifera.*)
17. Hime-ko-matsu.
18. Tsuga. (*Abies tsuga.*)
19. Hiba. (*Thujopsis dolabrata.*)
20. Akamatsu. (*Pinus densiflora.*)
21. Sugi. (*Cryptomeria japonica.*)
22. Keyaki. (*Planera japonica.*)
23. Shōji.
24. Sakura. (*Prunus pseudo cerasus.*)
25. Katsura. (*Cercidiphyllum japonicum.*)
26. Tchō Ginko biloba.
27. Igo.
28. Buna.
29. Shitan.
30. Tagayasan.
31. Karin.
32. Kuwa.
33. Keyaki. (*Planera japonica.*)
34. Ki-urushi (nami). Ordinary crude lacquer.
34 A. Ki-urushi (Jō-koshi) best filtered lacquer.
35. Seshime-urushi. Pure branch lacquer.
35 A. Seshime. Lacquer as sold.
36. Rō-urushi. Black lacquer.
37. Haguro. Tooth-dye. Broken, all contents gone.
38. Nakanuri-urushi. Middle painting lacquer.
39. Nuritate-urushi. Finishing lacquer.
40. Jō-hana-urushi.
41. Jō-chiu-urushi.
42. Jo-tame-urushi.
43. Shu-urushi. Vermilion lacquer.
44. Nashiji-urushi. Pear-basis lacquer.
45. Yoshino-urushi.
46. Yoshino-nobe-urushi. Yoshino spreading lacquer.
47. Seshime-urushi. Seshime spreading lacquer.
48. Shitamaki-urushi. Under-coat lacquer.
49. Ke-uchi-urushi. Inside line lacquer.
50. Shitamaki-nobe-urushi. Under-coat spreading lacquer.
51. Takamaki-urushi. Raised lacquer.
52. Rō-sé-urushi. Mixture of black and branch lacquer.
53. Kenna. Black liquid.
54. Hera. Spatula made of Hinoki. (3 specimens.)
55. Hake. Flat brush made from human-hair. (4 specimens.)
56. Kokuso. Finely-chopped hemp.

Keyaki is now known as *Zelkova acuminata*. Woods not identified by Quin are possibly as follows: *hime-ko-matsu*, *Pinus parviflora*; *shōji*, *Fraxinus platypoda*; *buna*, *Fagus crenata*; *shitan*, *Pterocarpus* sp.; *tagayasan*, *Clerodendrum wallichii*; *karin*, *Pseudocydonia sinensis*; *kuwa*, *Morus* sp.

159. Box of *tsaguru* lacquer over paper.

158. Tray of ordinary *tsaguru* lacquer.

REPORT ON LACQUER INDUSTRY.

57. Nuno. Hempen cloth.
58. Silk. Used for fine work.
59. Ji-no-ko. Burnt clay.
60. Tono-ko. Burnt clay from Mount Mari.
61. Hō-nō-ki-sumi. *Magnolia hypoleuca* charcoal.
62. Hiyakujikkō-sumi. *Largerstramia indica* charcoal.
63. Ara-to-ishi. Rough whetstone.
64. Shiro-to-ishi. White whetstone.
65. Awo-to-ishi. Green whetstone.
66. Nagura-to-ishi. From quarry at Nagura.
67. Tsuno-ko. Deers' horn ashes.
68. To-kusa. *Equisetum*.
69. Kaki-no-shibu. Persimmon juice.
70. Nikawa. Glue.
71. Yuyen-sumi. Lampblack.
72. Go-fun. Whiting.
73. Shō-no. Camphor.
74. Hōchō. Knife.
75. Yoshino. Paper.
76. Jo-ban. A box for pens, &c.
77. Tsuno-koban. Board for mixing ashes, &c.
78. Muro. Drying-press.
79. (*a*) Honji. Class I. Real basis. (Number of specimens, 34; 32 separate pieces.)
80. (*b*.) Kataji. Class II. Hard basis. (Number of specimens, 6.)
81. (*c*.) Handanji. Class III. Half-step basis. (Number of specimens, 8.)
82. (*d*.) Manzo. Class IV. (Number of specimens, 8.)
83. (*e*.) Ka-no-ji. Class V. Inferior basis. (Number of specimens, 6.)
84. (*f*.) Shibu-ji. Class VI. Persimmon-juice basis. (Number of specimens, 5.)
85. (*g*.) Sabi-sabi. Class VIII. Double Sabi. (Number of specimens, 10.)
86. (*h*.) Kaki-awase. Class VIII. Mixture or Kuro-Shunkei (black Shunkei). (Number of specimens, 2.)
87. (*i*.) Aka-Shunkei. Class IX. Red Shunkei. (Number of specimens, 2.)
88. (*j*.) Kijiro. Colour of the grain of wood. (Number of specimens, 14.)
89. (*k*.) Red and coloured lacquers—
 1. Coating of red lacquer ground down with magnolia charcoal.
 2. Pattern applied in black lacquer and gold.
 3. Coating of transparent lacquer applied.
 4. Finally polished.
 5. Best. 5 A. Second best.
 6. ,, 6 A. ,,
 7. ,, 7 A. ,,
 8. ,, 8 A. ,,
 9. ,, 9 A. ,,
 The same colours being used.
90. Shu. Vermilion.
91. Seishitsu. Green.
92. Kiō. Chrome yellow.
93. Bero-ai. Prussian blue.
94. Murasaki-ko. Purple powder.
95. White lead.
96. Tō-beni. Magenta roseine.
97. Benigara. Red oxide of iron.

98. Neji-fude. Brushes of rat's-hair. (Number of specimens, 2.)
99. U-no-ke-usuji-fude. Fine brushes made of hare's-hair. (2 specimens sent of each size.)
100. Ji-nuri-fude. Grounding brushes of hare's-hair. Five sizes. (2 specimens sent of each size.)
101. U-no-ke-hake. Flat brush of hare's-hair. (2 specimens sent.)
102. Mensō. Stiff brush of deers' hair. (2 specimens sent.)
103. Haké. Flat brushes of human hair. (2 specimens sent.)
104. Buu-mawashi. Compass, with brush attached.
105. Kébō. Brushes made of horse-hair. (6 specimens sent.)
106. Fude-kake. Brush-rest.
107. Fude-arai. Brush-cleaner.

162. Square trays, Made at Wojima.

160. Tray of *akita-noshiro* lacquer.

161. Round tray. *Chinkin-bori*. Made at Kaga.

The bigger plant looks most like a species of *Geranium*. Behind it are curving, narrow leaves belonging possibly to a species of *Ophiopogon* (Convallariaceae), commonly cultivated in Japan.

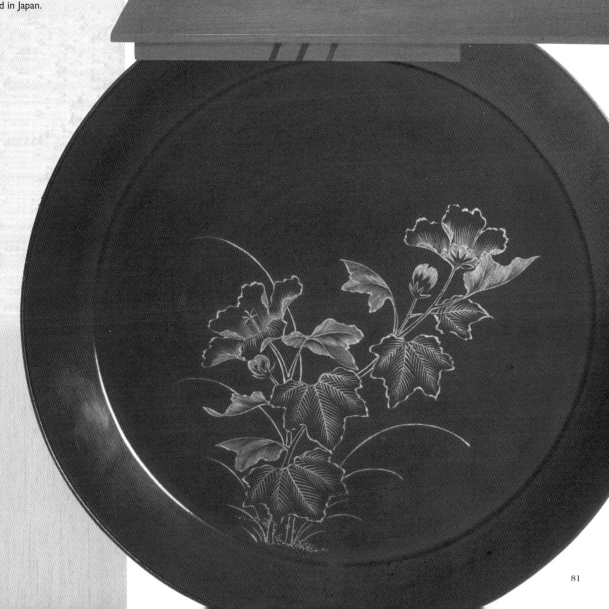

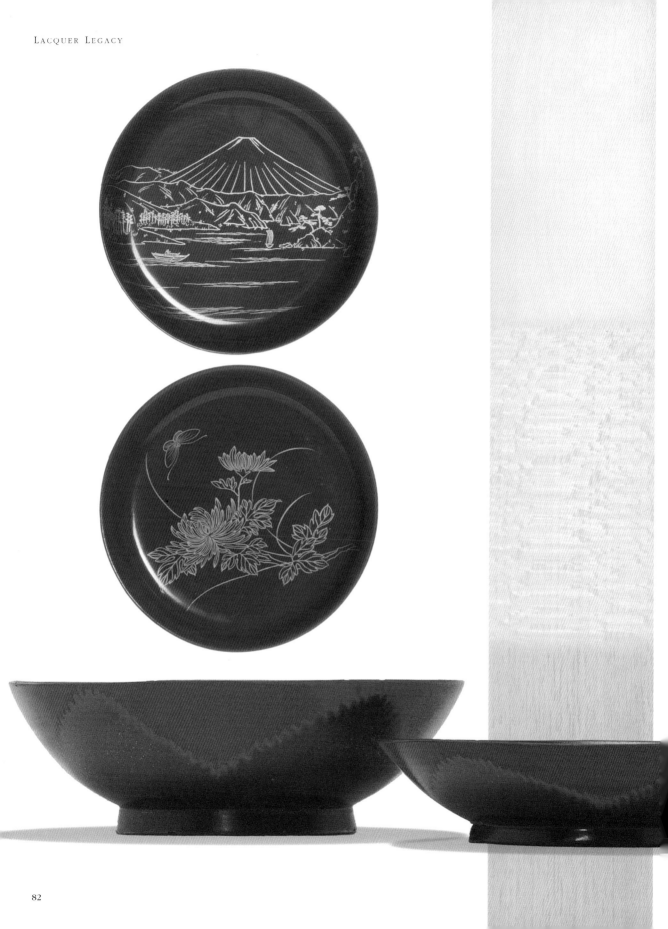

JAPAN.

108. Goma-abura. *Sesamum orientalis* oil.
109. Fude-ire. Brush-case.
110. { Tiutsu. Quills (three sizes).
 { „ Bamboo-tubes (three sizes).
111. Saji. Spoon.
112. Hirame-fude. Used in affixing hirame, &c. (2 specimens sent.)
113. Kujira-bera. Whalebone spatula. (2 specimens sent.)
114. Hera. Spatulas of Hinoki. Used for lacquer and sabi. (3 specimens of each sent.)
115. The tooth of a fish. Used for polishing.
116. A piece of polished shell. Used for smoothing paper.
117. Tsume-ban. Palette. (2 specimens sent.)
118 Take-ban. Small bamboo board.
119. Fun-bako. Flat lacquered box, for holding gold-dust.
120. Tsubaki-sumi. Camellia charcoal.
120 A. Camellia charcoal-powder.
121. Shiō. Gomboge.
122. Ye-abura. *Perilla ocymoides* oil.
123. Specimen board, containing 110 samples of yasuri-ko, hirame, nashiji and sundry colours, &c.
124. Tin-nashiji.
125. Tin-dust.
125 A. Burnt tin-dust.
126. Specimen of Togidashi. Branch of a lacquer tree—
 1 and 2. Showing outline and veining.
 3. Powdering of gold-dust.
 4. Application of second coating of rō-sé.
 5. Coating of Rō.
 6. Same, ground roughly with magnolia charcoal.
 7. Second coating of Rō to the finish.
127. Specimen of Togi-dashi. Water and clouds—
 1 to 3. Outline, veining and powdering with yasuri-ko and hirame.
 4. Application second coating of rō-sé.
 5 Coating of Rō
 6. Same, ground roughly with magnolia charcoal.
128. Specimen of Togi-dashi on Tagaya-san. Branch of rose
 1. Outline of pattern.
 2. Veining.
 3. Powdering of gold-dust.
 4. Coating of Rō-sé.
 5. Coating of transparent lacquer.
 6. Ground down with magnolia charcoal.
 7. Second coating of transparent lacquer.
 8. Again ground with magnolian charcoal.
 9. Thin coating of transparent lacquer applied with cotton wool.
 10. Polished with to-no-ko and deer's-horn.
 11. Thin coating of yoshino lacquer.
 12. Polished with deer's-horn ashes.
 13 and 14. Repetition of 11 and 12.
129. Specimen of Hiramakiye. Flat lacquer on Shitan (bamboo)—
 1. Outline of pattern.
 2. Pattern filled in with Shitimaki lacquer.
 3. Powdered with gold.
 4. Coating of Yoshino lacquer.
 5. Ground with camellia charcoal.
 6. Polished with whetstone-powder and oil.
 7. Veining drawn in Ke-uchi lacquer.
 8. Same, powdered with gold.
 9. Thin coating of Yoshino lacquer.
 10. Polished with powdered-whetstone and oil.
 11. Thin coating of Yoshino-nobe lacquer and water.
 12. Polished with whetstone-powder and oil.
130. Specimen of Takamakiye. Raised gold lacquer over clouded Togidashi—
 1. Corresponding with No. 6 of Togidashi. (Specimen Nos. 126 and 127.)
 2. Second coating of Rō.
 3. Ground down with magnolia charcoal.
 4. Polished with Tonoko and camellia charcoal.
 5. Polished with deer's-horn ashes, after a coating of Yoshino lacquer.

164. Small round trays of Kaga lacquer.

163. Sweet meat bowls made at Wajima.

166. (*a*.) Food box. Black Aidzu-ware.

166. (*d*.) Tray. Red and green Aidzu-ware.

REPORT ON LACQUER INDUSTRY.

 6. Camellia charcoal powder dusted over a coating of Shitamaki lacquer.
 7. Coating of Takamaki lacquer over two applications of Yoshino-nobe lacquer.
 8. Same, ground with magnolia charcoal, and partly polished with camellia charcoal.
 9. Polished with Tonoko and oil.
 10. Application of Keshi-fun over Shitamaki lacquer.
 11. Application of Komaka-me-mijin over Shitamaki lacquer.
 12. Coating of Yoshino lacquer.
 13. Polished with powdered-whetstone and oil.
 14. Final polishings. Nos. 12 and 13 repeated three times.

130 A. Paper pattern used for producing above, with lacquer tracing on back, together with the other paper patterns used—
 1. Specimen of prepared paper used for tracing patterns.
 2. Specimen of soft paper used for rubbing-off the thin coats of lacquer.

131. Specimen of Takamakiye on plain black ground. Branch of lacquer tree—
 1. First tracing.
 2. Coating of Shitamaki lacquer and charcoal-powder; two coats of Yoshino-nobe lacquer. Afterwards ground smooth with magnolia charcoal.
 3. Coating of Takamaki lacquer.
 4. Ground with magnolia charcoal, and polished with Tonoko and oil.
 5. Gold-dust sprinkled over a coating of Shitamaki lacquer.
 6. A coating of Yoshino-nobe lacquer.
 7. Ground with camellia charcoal and polished with powdered-whetstone and oil.
 8. Veining, and subsequent polishing three times.

132. Specimen of raised lacquer, with and without subsequent gilding. Branch of fir-tree and creeper—
 (The marking on the background is meant to imitate the surface of metal attacked by verdigris.)
 1. Outline drawn and sprinkled with charcoal-dust.
 2. Spikes of fir-tree, finished in Hira-makiye.
 3. Three applications of Shitamaki lacquer and charcoal-powder, afterwards polished.
 4. Coating of Takimaki lacquer, polished with camellia charcoal-powder and Tonoko.
 5. Leaves powdered with gold, over a coating of Shitamaki lacquer.
 6. Coating of Yoshino-nobe lacquer, afterwards ground with camellia charcoal, and polished with powdered whetstone and oil.
 7. Finished branch of tree made of several coats of Sabi lacquer.
 8. One finished leaf, showing application of Kiri-kane; and one finished leaf showing method of shading with vermilion.

133. Specimen of raised gold lacquer on plain wood (branch and blossom of cherry). The very bright portions are in thin gold-foil (Kimetsuke).
134. Finished specimens of Giyōbu-nashiji, of mixed gold and shell work, and of pattern for a border.
135. Specimen of lacquering on metal.
136. Tray showing process of applying Nashiji—
 1. Pure gold Nashiji.
 2. Koban gold Nashiji.
 3. Silver Nashiji. Back of tray silver Nashiji.
 4. Tin Nashiji.
 5. Coating of transparent lacquer.
 6. Ground roughly with magnolia charcoal.
 7. Second coating of transparent lacquer.
 8. Ground smooth with magnolia charcoal.
 9. Transparent lacquer applied with cotton-wool.
 10. Polished with powdered charcoal and tonoko.
 11. Thin coating of Yoshino lacquer.
 12. Polished with deer's-horn ashes and oil.
 13. Second thin coating of Yoshino lacquer.
 14. Polished with deer's-horn ashes and oil.

136 A. Specimen of common tin Nashiji.
137. Finished specimen of Togidashi. Peacock's feather.
138. Box showing various modes of applying Kiri-kane, Awo-gai, Hirame, and shading colours to produce patterns (unfinished).

JAPAN.

139. Similar kind of box (finished).
140. Specimen of inlaying work: in coral, various shells, deer's-horn, &c.—
 1. Hirame applied over Rō-sé.
 2. Shell-work, &c., having been applied, three coats of Sabi have been given, and then ground smooth.
 3. Coating of Rō lacquer.
 4. Same, ground down with magnolia charcoal.
 5. Second coating of Rō lacquer, same ground away with magnolia charcoal and polished with Tonoko and oil.
 6. A coating of branch lacquer, afterwards polished off with deer's-horn ashes and oil.
 7. Hirame. Polished after lacquering.
 8. The whole of the inlaid work polished and the veining of the leaves completed; bottom of tray in silver Nashiji.
141. Stand for wine cup in Togidashi. Kioto work. About fifty years old.
142. Inrō. Medicine-box in Takamakiye, with dead gold ground, showing application of Kuma (shading lacquer). Tōkiō work. About twenty-five years old.
143. Inrō. Medicine-box, showing application of hirame. Tōkiō work. Estimated at over one hundred years old.
144. Inrō. Medicine-box, showing method of shading, &c. Tōkiō work. About eighty to one hundred years old.
145. Tray. Inlaid shell-work. Kioto work. Estimated age, one hundred and twenty years.
146. Tray. Negoro ware. *Vide* Pamphlet, pp. 10-11. Over fifty years old.
147. Medicine-box of Tsuishu. *Vide* Pamphlet, p. 16. Estimated over fifty years old.
148. Box of Tsui-koku. Carved black lacquer. *Vide* Pamphlet, p. 16. Estimated age, over one hundred years.
149. Two boxes of the style called "Guri." *Vide* Pamphlet, p. 16. Estimated age, over fifty years.
150. Writing-box, style called "Cho-moku." *Vide* Pamphlet, p. 9. Estimated age, seventy to eighty years.
151. Wine-cup. Kioto work. Red and yellow lacquer. Gilt inside. Estimated age, over fifty years.
152. Soup or rice-bowl. Nambu-ware. *Vide* Pamphlet, p. 10. Estimated age, over seventy years.
153. Round tray. Loo-choo red lacquer.
154. Paper tray lacquered over. Tōkiō work
155. Specimen boards, showing design on red lacquer, in gold, and rō-sé, through transparent lacquer. Tōkiō work.
156. Food-box of Wakasa lacquer. *Vide* Pamphlet, p. 13.
157. Cabinet of Tsugaru-nishiki lacquer.
158. Tray of ordinary Tsugaru lacquer.
159. Box of Tsugaru lacquer over paper. *Vide* Pamphlet, p. 13.
160. Tray of Akita-noshiro lacquer. *Vide* Pamphlet, p. 12.
161. Round tray. Chinkin-bori. Made at Kaga. Also, rice-bowl. *Vide* Pamphlet, p. 17.
162. Square trays. Made at Wojima. *Vide* Pamphlet, pp. 14 and 17.
163. Sweetmeat bowl. Made at Wajima. *Vide* Pamphlet, p. 14.
164. Small round trays of Kaga lacquer.
165. Toothbrush-box of Suruga lacquer, showing grain of the wood. *Vide* Pamphlet, p. 16.
166. (*a.*) Food-box. Black Aidzu-ware.
 (*b.*) Rice-bowl. Yellow ditto.
 (*c.*) ,, Green ditto.
 (*d.*) Tray. Red and green ditto.
 (*e.*) ,, Yellow clouded ditto.
 (*f.*) Rice-bowl. Reddish brown ditto.
167. 1 square and 1 round tray of new Nikkō-ware.
168. Food-box. Red Shunkei.
169. Square tray. Ditto.
170. Rice-box. Commonest red Shunkei. Made in Province of Shinano.

THE QUIN REPORT

166. (c.) Rice bowl. Green Aidzu-ware.

166. (b.) Rice bowls. Yellow Aidzu-ware.

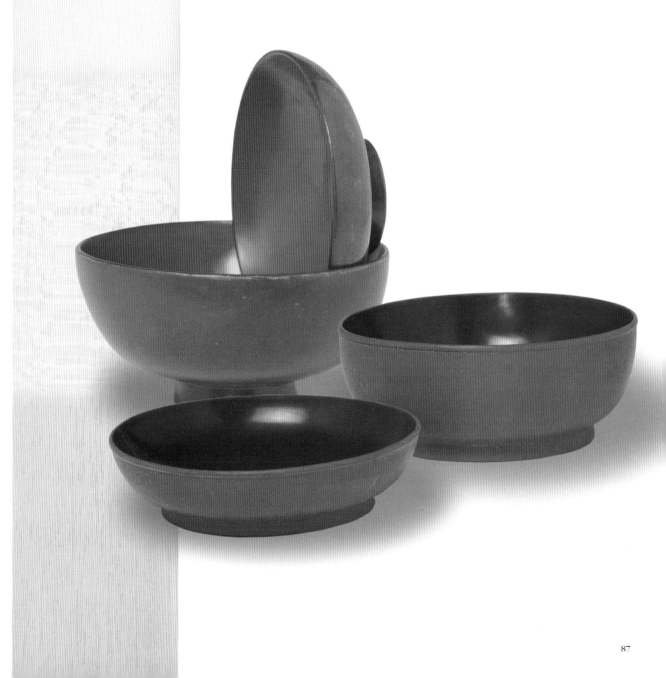

166. (*f.*) Rice-bowls. Reddish brown Aidzu-ware.

THE QUIN REPORT

167. Square tray of new Nikkō-ware.

168. Food-box. Red Shunkei.

89

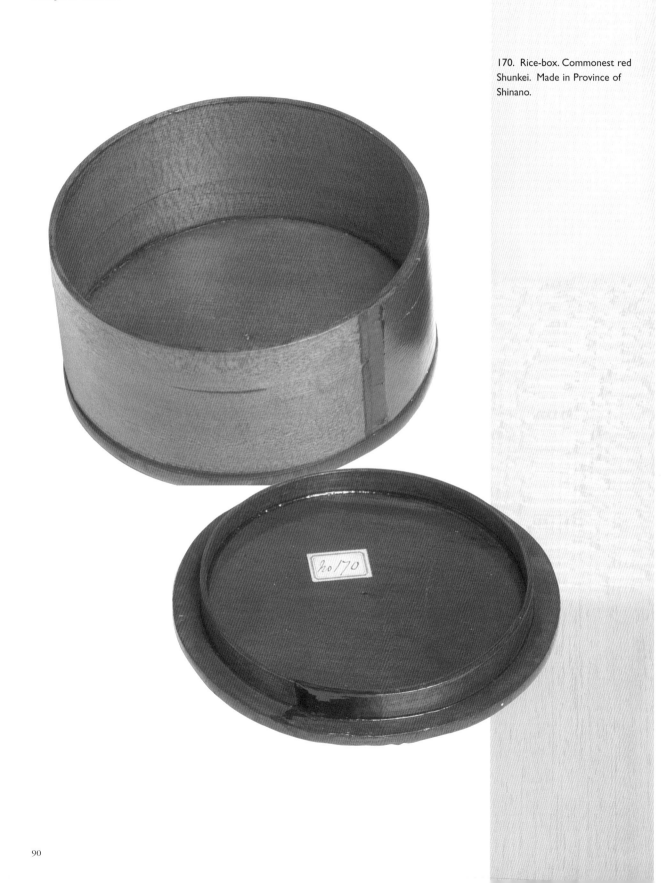

170. Rice-box. Commonest red Shunkei. Made in Province of Shinano.

collection index

Quin's catalogue no.	Economic Botany Collections (EBC) no.	brief description	refer to page	pictured on page
1-7, 9	67859	tapping tools	37	35
27-33	67851	woods used	43	36
34-36, 38-53	67832-67837 67860-67874 68577	lacquer samples	44	38
54, 113, 114	67812	spatulas	49	41
65	67924	whetstone	50	41
68, 70, 74, 110	68563	tools	50, 65	42
76	67833	box for pens	50	42
78	unnumbered	drying-press	50	45
82, 88	67857	lacquer applications	52	45
89	67854	lacquer coatings	60	46

Quin's catalogue no.	Economic Botany Collections (EBC) no.	brief description	refer to page	pictured on page
99-102	68565	brushes	63	46
55, 104, 105, 107	68562	brushes	49, 65	48
109, 111, 112, 115-118	68564	tools	65	48
119	67832	box for gold dust	65	48
123	69692	specimen board	65	51
126	68569	*togi-dashi*	69	54
127	68570	*togi-dashi*	69	52
128	68575	*togi-dashi* on *tagaya-san*	69	53
129	68572	*hiramakiye*	70	53
130	67829	*takamakiye*	72	53
130 A	75979	paper pattern for 126 & 131	72	55

INDEX TO QUIN'S REPORT

Quin's catalogue no.	Economic Botany Collections (EBC) no.	brief description	refer to page	pictured on page
131	68568	*takamakiye*	72	54
132	67850	raised lacquer	72	57
130 A	75980	paper pattern for 132	72	57
134	68566	*giyōbu-nashiji*	76	58
135	68567	lacquering on metal	75	58
136	67845	*nashiji* application	76	61
136 A	68571	common tin *nashiji*	76	61
137	67818	finished *togi-dashi*	69	52
138	67813	patterned box (unfinished)	-	62
139	67813	patterned box (finished)	-	62
140	68557	inlaying work	-	64

Laquer Legacy

Quin's catalogue no.	Economic Botany Collections (EBC) no.	brief description	refer to page	pictured on page
141	67825	*togi-dashi* wine cup stand	69	64
142-144	68553-68555	medicine-boxes	72	67
145	68556	inlaid shell-work	-	68
146	67848	Negoro-ware	10 in Quin 1881[1]	68
147	68573	*tsuishu* medicine-box	16 in Quin 1881	71
148	67828	*tsui-koku* box	16 in Quin 1881	71
149	67840	"Guri" box	16 in Quin 1881	71
151	67827	wine-cup, Kioto	16 in Quin 1881	73
153	67820	*loo-choo* red lacquer	16 in Quin 1881	73
154	67841	lacquered paper tray	16 in Quin 1881	74
155	67824	specimen boards	16 in Quin 1881	74

[1] See References, page 99.

INDEX TO QUIN'S REPORT

Quin's catalogue no.	Economic Botany Collections (EBC) no.	brief description	refer to page	pictured on page
156	67826	Wakasa lacquer	13 in Quin 1881	77
157	67737	*tsugaru-nishiki*	13 in Quin 1881	77
158	67844	*tsugaru* lacquer	13 in Quin 1881	78
159	67822	*tsugaru* lacquer	13 in Quin 1881	78
160	67846	*akita-noshiro* lacquer	12 in Quin 1881	81
161	67839	*chinkin-bori*, Kaga	17 in Quin 1881	81
162	67816	trays, Wajima	14, 17 in Quin 1881	81
163	67815	bowl, Wajima	14 in Quin 1881	82
164	68574	Kaga lacquer	17 in Quin 1881	82
166a	68561	black Aidzu-ware	63	84
166b	67819	yellow Aidzu-ware	63	87

Laquer Legacy

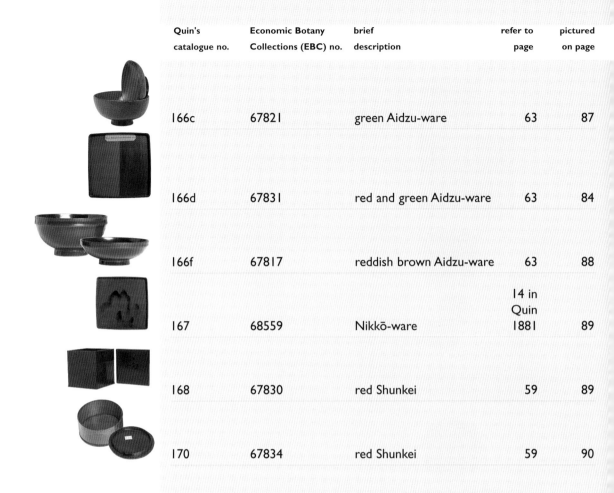

Quin's catalogue no.	Economic Botany Collections (EBC) no.	brief description	refer to page	pictured on page
166c	67821	green Aidzu-ware	63	87
166d	67831	red and green Aidzu-ware	63	84
166f	67817	reddish brown Aidzu-ware	63	88
167	68559	Nikkō-ware	14 in Quin 1881	89
168	67830	red Shunkei	59	89
170	67834	red Shunkei	59	90

References

The archival material consulted was: 1) *Miscellaneous Reports. Japan. Lacquer, 1881-1902*. Archives of the Royal Botanic Gardens, Kew; 2) FO 46 at the Public Record Office, Kew.

Anon. 1994. *Japanese paper gone abroad. From the exhibition of (Parkes) collections.* Museum of Tobacco and Salt; Gifu Museum of History, Museum of Paper, Tokyo. [In Japanese.]

Arakawa, H., Yamamoto, H. & Takamori, H. 1997. *Genuine Japanese lacquer-ware – choice and maintenance.* Shinchosha, Tokyo. (In Japanese.)

Bretschneider, E. 1898. *History of European botanical discoveries in China.* K.F. Koehler's Antiquarium, Leipzig.

Burmester, A. 1983. Article in *Archaeometry* 25: 45, discussed in Anon. 1983. New technique exposes fake lacquer. *New Scientist* 98: 149.

Cheng Mien & Ming Tien Iu. 1980. *Flora Reipublicae Popularis Sinicae.* Tomus 45(1). Science Press. (In Chinese.)

Dai Nippon Nokai. 1891. *Useful plants of Japan*, written by Y. Tanaka and M. Ono, illustrated by Setsusai Hattori. Tokyo. (In Japanese.)

Daniels, G. 1996. *Sir Harry Parkes. British representative in Japan 1865-83.* Japan Library/Curzon Press, Richmond.

Dauncey, E., Rayner, T. & Shah-Smith, D. 2000. *Poisonous plants and fungi of Britain and Ireland on CD-ROM.* Royal Botanic Gardens, Kew and Guy's and St Thomas's Hospital Trust.

Desmond, R. 1995. *Kew. The history of the Royal Botanic Gardens.* The Harvill Press, London with The Royal Botanic Gardens, Kew.

Desmond, R. 1999. *Sir Joseph Dalton Hooker: traveller and plant collector.* Antique Collectors' Club, Woodbridge.

Fortune, R. 1857. *A residence among the Chinese: inland, on the coast, and at sea.* John Murray, London.

Fortune, R. 1863. *Yedo and Peking. A narrative of a journey to the capitals of Japan and China.* John Murray, London.

Harborne, J.B. & Baxter, H. 1996. *Dictionary of plant toxins.* John Wiley & Sons, Chichester.

Hertslet, E. (Comp.) 1897. *The Foreign Office List, 1897, forming a complete British diplomatic and consular handbook etc.* Harrison and Sons, Pall Mall.

Hillier Nurseries. 1996. *The Hillier manual of trees and shrubs.* David & Charles, Newton Abbot.

Hoare, J.E. 1997. Britain's Japan Consular Service, 1859-1941. In Nash, I. (Ed.). *Britain and Japan: biographical portraits*, Vol. II, 94-106. Curzon Press, London.

Hooker, J.D. 1879. *The flora of British India.* Vol. II. L. Reeve & Co., London.

Huth, H. 1971. *Lacquer of the West.* University of Chicago Press, Chicago.

Huxley, A., Griffiths, M. & Levy, M. (Eds). 1992. *The new Royal Horticultural Society dictionary of gardening. 4. R to Z.* The MacMillan Press, London.

Isaacs, R. & Blurton, T.R. 2000. *Visions from the golden land. Burma and the art of lacquer.* British Museum Press, London.

Jaeschke, H.F. 1985 Oriental lacquer analysis: thin-section and electron microprobe. In England, P.A. & van Zelst, L. (Eds), *Applications of science in the examination of works of art,* 217-220. Museum of Fine Arts, Boston.

Jaeschke, H.F. 1992. Oriental lacquer: a natural polymer. In Allen, N.S. & Horie, C.V. (Eds), *Polymers in conservation*, 47-61. Royal Society of Chemistry, London.

Kenjo, J. 1988. Scientific approach to traditional lacquer art. In Brommelle, N.S. & Smith, P. (Eds), *Urushi*, 155-162. The Getty Conservation Institute, Marina del Rey, California.

Kidder, J.E. 1959. *Ancient peoples and places.* Thames & Hudson, London.

Kumanotani, J. 1988. The chemistry of oriental lacquer (Rhus verniciflua). In Brommelle, N.S. and Smith, P. (Eds), *Urushi*, 234-251. The Getty Conservation Institute, Marina del Rey, California.

Lack, H.W. 1999. Plant illustration on wood blocks. A magnificent Japanese xylotheque of the Early Meiji period. *Curtis's Botanical Magazine* 16(2): 124-134.

Lancaster, R. 1989. *Travels in China. A plantsman's paradise*. Antique Collector's Club, Woodbridge.

Leslie, J.B. 1911. *Armagh clergy and parishes: being an account of the clergy of the Church of Ireland in the diocese of Armagh, from the earliest period, with historical notices of the several parishes, churches, &c*. William Tempest, Dundalk.

Mac Lean, J. 1978. Von Siebold and the importation of Japanese plants into Europe via the Netherlands. *Japanese Studies in the History of Science* 17: 43-79.

Mitchell, A.F., Schilling, V.E. & White, J.E.J. 1994. *Champion trees in the British Isles*. Technical Paper 7. Forestry Commission, Edinburgh.

Morrow, V. 1986. Bibliotheca Quiniana. In P. Fox (Ed.), *Treasures of the Library. Trinity College Dublin,* 184-196. Royal Irish Academy, Dublin for the Library of Trinity College Dublin.

Nakasoto, T., Emoto, Y. & Ishikawa, R. 1971. Notes on the structure and technique of a Neolithic comb of lacquerwork unearthed at the Sanno site, Miyogi Prefecture, and preservation treatment. *Science for Conservation* 7: 47-60.

Parkes, H.S. 1871. *Reports on the manufacture of paper in Japan presented to both Houses of Parliament by command of Her Majesty*. Harrison and Sons, London.

Ponsonby, L. 1990. *Marianne North at Kew Gardens*. Webb & Bower, in association with the Royal Botanic Gardens, Kew.

Powell, S.M. & Barrett, D.K. 1986. An outbreak of contact dermatitis from Rhus verniciflua (Toxicodendron vernicifluum). *Contact Dermatitis* 14: 288-289.

Quin, J.J. 1881. The lacquer industry of Japan. *Transactions of The Asiatic Society of Japan* IX: 1-30.

Quin, J.J. 1882. *Report by Her Majesty's Acting Consul at Hakodate on the lacquer industry of Japan. Foreign and Consular reports for Japan and Siam 1879-1883*. Harrison and Sons, London.

Rein, J.J. 1889. *The industries of Japan*. Hodder and Stoughton, London.

Royal Horticultural Society. 1997. *The RHS plant finder 1997-98*. Dorling Kindersley, London.

Stearn, W.T. 1999. Engelbert Kaempfer (1651-1716). Pioneer investigator of Japanese plants. *Curtis's Botanical Magazine* 16: 103-115.

Tyman, J.H.P. 1979. *Chem. Soc. Rev.* 8: 499; in Harborne and Baxter 1996 (above).

Watt, G. 1892. *A dictionary of the economic plants of India.* Volume VI, Part 1 – B. Published under the Authority of the Government of India, Department of Revenue and Agriculture. W.H. Allen & Co. London; Office of the Superintendent of Government Printing, Calcutta.

Webber, P. 1995. The Parkes Collection of Japanese paper. *V&A Conservation Journal* April: 5-9.

Webber, P. & Thompson, A. 1991. An introduction to the Parkes Collection of Japanese papers. *The Paper Conservator* 15: 5-16.

Zhao, G. & Hu, Z. 1989. Ultrastructure of the secretory cell of lactiferous canals of Rhus verniciflua at different developmental stages. *Chinese Journal of Botany* 1: 49-55.